A Guide to the National Gallery

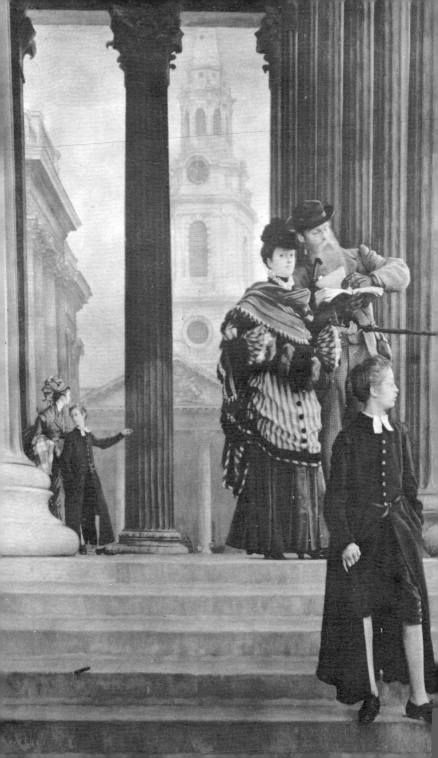

A Guide to
the National Gallery

Homan Potterton

With a Foreword by Michael Levey
and over 160 Illustrations

Published by Order of the Trustees, The National
Gallery, London

© Homan Potterton and The National
Gallery, 1976
First edition April 1976
Reprinted August 1976

Front Cover

Giovanni di Paolo (d. 1482) *S. John the
Baptist retiring to the desert* (detail)

Back Cover

Rubens (1577-1640) *A Roman Triumph*
(detail)

Photographs on front and back covers
taken in the National Gallery

Frontispiece

James Tissot (1836-1902) 'London
Visitors'
33 × 22
Toledo Museum of Arts, Ohio
Exhibited at the Royal Academy in
1874 the view is through the portico of
the National Gallery towards the
Church of S. Martin-in-the-Fields.
Although provided with a guide book,
the couple would seem to be leaving the
Gallery by as early as ten-thirty in the
morning.

Acknowledgements

Landseer's portrait of *Queen Victoria and
Prince Albert* and David Allan's drawing
of an *English Traveller in Rome* are
reproduced by gracious permission of
Her Majesty the Queen.
Tissot's '*London Visitors*' is reproduced
by permission of the Toledo Museum of
Arts, Toledo, Ohio, gift of Edward
Drummond Libbey; Orpen's *Homage to
Manet* by permission of the City Art
Gallery, Manchester. Portraits of Boxall
by Pittatore, Poynter by Burne-Jones,
Holroyd by Strang and the sketch of Sir
Robert Peel by permission of the
National Portrait Gallery, London.
Partridge's cartoon '*Hans across the Sea*' is
reproduced by permission of the Editor
of *Punch*. One of the photographs on the
cover by permission of Associated
Newspapers Group Ltd.

Designed by James Shurmer

Printed by T. and A. Constable Ltd,
Edinburgh

Contents

Foreword by Michael Levey 7

How to use the Guide 9

1. Introduction 11

2. The Early Italian Schools 23

3. The Early Netherlandish and German Schools 39

4. The Sixteenth and Seventeenth Century Italian Schools 55

5. Rembrandt and the Dutch School 75

6. Flemish, French and Spanish Painters of the Seventeenth Century 93

7. The Eighteenth Century 113

8. From 1824 to the present day 129

9. The Galleries on the Lower Floor 147

General Index 164

Index to Rooms and Schools of Painting 168

Plan of the National Gallery, *inside back cover*

The first six Directors of the National Gallery

Top row, left to right:
Sir Charles Eastlake
(1855-1865)
Sir William Boxall
(1866-1874)

Centre row, left to right:
Sir Frederick Burton
(1874-1894)
Sir Edward Poynter
(1894-1904)
Sir Charles Holroyd
(1906-1916)

Bottom row:
Sir Charles Holmes
(1916-1928)

Subsequent directors have been:
Sir Augustus Daniel
(1929-1933)
Sir Kenneth Clark
(1934-1945)
Sir Philip Hendy
(1945-1967)
Sir Martin Davies
(1968-1973)

Foreword by Michael Levey,
Director of the National Gallery

The superb and extensive treasures of several centuries of European painting in the National Gallery need some guidance if they are to be fully enjoyed. This book is planned to offer a friendly, helpful hand to the so-called ordinary visitor whom we do not think 'ordinary' at all, and whose eye and appetite are likely to be at least as keen as those of the expert or scholar. For the latter there are, anyway, the Gallery's own detailed catalogues to study and ponder on.

What Homan Potterton provides in his entertaining, instructive text is at once a concentrated history of European painting and a room-to-room commentary on the Gallery's own finest examples of it. He touches, too, on how the Collection has been built up, until today it can be claimed to be possibly the most sheerly balanced and representative of all national collections of European painting. Something of the secret of its strength lies, I believe, in the fact that it remains comparatively small.

That means that a guide to it is feasible. A guide to it ought also to be enjoyable reading, reflecting the joy of walking through rooms of great pictures, where each of us may freely exercise his or her individual taste. No one should try and like _every_ masterpiece by _every_ painter. The percipient reader will detect places where Homan Potterton hints at his own taste—and thus encourages reaction. Reaction is what all the painters of the pictures in the Gallery would have wished their work to stimulate. Looking at pictures is a complicated and active process, prompting us to ask a myriad questions about why and how they appear as they do. We shall never obtain all the answers—which is one reason why we go on looking; but many of the questions a visitor may reasonably begin by asking will be found unobtrusively answered in the crisp company of this guide.

A view of the Vestibule in the National Gallery
taken early this century.
Subsequent changes have included the installation
of the mosaic pavements.

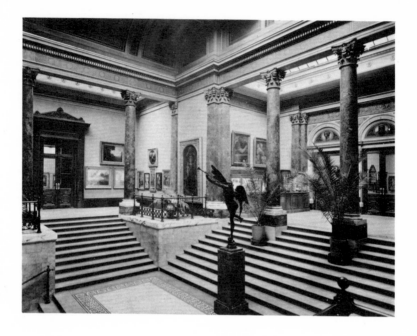

How to use the Guide

The Guide contains commentaries on about 150 pictures which are exhibited on the main floor, and some information on assorted pictures from the Lower Floor Galleries.

At the back of the book are two indices, a General Index and a Room Index.

The visitor who wants to know where to find, for example paintings by Titian, should refer to the General Index; but standing for example in Room 23 and wanting to know what pictures from that room are discussed, he should refer to the Room Index.

In both indices numerals given in *italic type* refer to page numbers, otherwise they refer to illustrations.

Visitors should take into account the occasional re-hanging of some pictures.

Measurements throughout are given in inches, height preceding width.

1 Introduction

G. Gabrielli (19th century)
Room 32 at the
National Gallery in 1886

Correggio's '*School of Love*' is visible in
the background and also paintings by
Lanino, Girolamo dai Libri and
Morando.

England, among her European neighbours, was almost the last to establish a 'national' gallery. The Vienna Gallery had opened in 1781, Paris in 1793, Amsterdam in 1808, Madrid in 1809, and a year before the National Gallery was founded in London, Berlin in 1823. In that year an English private collector, Sir George Beaumont, offered his small but choice collection of Old Master paintings to the Nation if a suitable building was provided to house them. His offer was still open the following year when another important collection, that of the late John Julius Angerstein, came on the market in London. The Treasury, finding itself unexpectedly rich as a result of the repayment by the Austrian Government of two loans (made by Britain in 1795 and 1797 to bring Austria into war against the French), purchased the Angerstein Collection for £57,000; and this collection, thirty-eight paintings, became the nucleus of the new National Gallery.

The public saw their pictures for the first time on May 10th, 1824, when they were exhibited in Angerstein's former town house in London (fig 1). The critic William Hazlitt hoped that the new Gallery would provide 'a cure . . . for low thoughted cares and uneasy passions'; but others had less selfish expectations of England's National Gallery. Sir George Beaumont anticipated that 'by easy access to such works of art the public taste might improve'; while Lord Farnborough (one of the first Trustees) was more wary and thought that 'those in inferior stations would find great difficulty in attaining a taste for the liberal arts'. Sir Robert Peel on the other hand (later Prime Minister) felt that the National Gallery would 'not only contribute to the cultivation of the arts, but also to the cementing of the bonds of union between the richer and poorer orders . . . '; and the painter Benjamin Robert Haydon foresaw an 'improvement in manufactures' and a boost to British exports.

Whether the sight of the Angerstein pictures improved or disimproved the passions, taste or social behaviour of any of the twenty-four thousand people who saw them within the first seven months (or indeed any of the two million who to-day see them annually) is difficult to discern; and as regards British exports, they seem if anything to have declined (in the present century at least), according as the collection has increased. It is therefore perhaps sufficient to say that in 1824 a Gallery

was founded which still survives over one hundred and fifty years later; and that from the initial thirty-eight pictures, the collection has swelled to over two thousand and has become one of the truly great picture galleries of the world.

It is hardly necessary to point out that the building in Trafalgar Square (fig. 2) which to-day houses the National Gallery is neither the former town-house of John Julius Angerstein nor indeed, of anyone else. This building, designed by William Wilkins (1778-1839), was built as the National Gallery and opened to the public in 1838. Although many additions have been made since then the façade which dominates the square from the north side is still substantially the same. The site, though prominent was difficult, being exceptionally long and also narrow; and it was required that the façade of the new building should not interrupt the view from Pall Mall East to the portico of S. Martin-in-the-Fields. Wilkins's brief was to provide a series of top lit galleries on either side of an entrance hall, with offices running underneath. Thus the façade had to be a long one with windows on the ground floor but none above them; and the principal entrance was to lead directly from the street onto the main floor. Wilkins's solution to the latter problem, the magnificent portico, is the most successful feature of his design, and encouraged by its effect, he articulated the façade further with 'pavilions' created by columns and pilasters.

'To make his design still more "interesting" ', Sir John Summerson has suggested, 'Wilkins set a dome over the portico and turrets over the terminal pavilions, like the clock and vases on a mantelpiece, only less useful.' Other 'interesting' features are presumably the sculptures which occupy assorted niches on the building. These (with the exception of Flaxman's *Britannia* who masquerades as *Minerva* on the east end) are by Charles Rossi (1762-1839), and were originally executed for the Marble Arch (though never erected). Within the portico, and above the principal doorway, two silly and shameless women, seated respectively on a camel and a horse, usher visitors inside.

The effect created by the interiors of the Gallery owes less to Wilkins than to the later architects who provided a succession of extensions to the original building (fig 3). The earlier entrance hall and staircases were remodelled

between 1884 and 1887 by Sir John Taylor (1833-1912) who created the splendid vestibule which the visitor sees to-day. To the east, behind Wilkins's suite of rooms, E. M. Barry (1830-1880) added a dome, four radiating 'chapels' and three other rooms between 1872 and 1876. Extensions to the west wing have been made this century culminating with the opening in 1975 of thirteen new exhibition rooms. Writing to *The Times* in 1852, John Ruskin deplored the fact that 'the popular idea of a national gallery is that of a magnificent palace' and he pointed out that 'the two imperative requirements (of a national gallery should be) that every picture in the gallery should be perfectly seen and perfectly safe'. Few people to-day would argue with these principles, and the new Northern Extension, as far as architecture is concerned, is a model of discretion and reticence in comparison to the grandeur of the Victorian interiors. The visitor who pauses in the vestibule may be amused by a facetious 20th-century addition: the mosaic pavements, executed by a Hungarian artist Boris Anrep in 1933 and 1952, show amongst others, Greta Garbo as *Melpomene*, Virginia Woolf as *Clio* and Winston Churchill (not surprisingly) as *Defiance*. The poet T. S. Eliot in continuous contemplation of the Loch Ness Monster is intended to epitomise a Briton's notion of *Leisure*.

From its inception the Gallery was administered by a Board of Trustees, who entrusted its day-to-day administration to a Keeper and an Assistant Keeper. The duties of the Keeper and Assistant Keeper included the display of the collection, the writing of catalogues, and the cleaning of the paintings. It was not until 1855 (when the offices of Keeper and Assistant Keeper were retained) that the post of Director was established, and since that date the Gallery has had ten Directors. To-day the National Gallery is administered by a Director, a Keeper, two Deputy Keepers and three Assistant Keepers; while the cleaning and conservation of the pictures is undertaken by a separate department of specialist restorers. Their work is assisted by the Scientific and Photographic Departments: the former conducts research into the conditions in which paintings should ideally be exhibited, analyses the pigments employed by different artists, and generally provides scientific information which assists in the conservation and cataloguing of the collection. The latter is responsible for providing slides and also photo-

graphic material used in the Gallery's publications, as well as for technical photography of paintings undergoing restoration. The Publications Department, originally set up by the Trustees in 1915, operates on the lines of an independent trading company and profits from popular publications and postcards are used to subsidise less profitable ventures which are deemed essential to the Gallery, for example the publication of detailed catalogues.

British painting was represented at the National Gallery from the start, and indeed the Angerstein Collection included Reynolds's famous portrait of *Lord Heathfield* and Hogarth's series *Marriage à la Mode*. In 1897 the Tate Gallery was opened to house the more modern British paintings, and in 1910 many of the paintings which the artist Turner bequeathed to the National Gallery were transferred there. Subsequently most of the National collection of British paintings have been transferred to the Tate, and only a token collection of a few masterpieces is now exhibited at Trafalgar Square.

In 1824, when the establishment of a National Gallery was being discussed, the Chancellor of the Exchequer (referring to Sir George Beaumont's offer to give his collection to the Nation), expressed himself 'sanguine in . . . (the) . . . hope, that the noble example would be followed by many similar acts . . . the result of which will be the establishment of a splendid Gallery . . . worthy of the nation'. The Chancellor's hopes were indeed well-founded, for of the National Gallery's collection of over two thousand paintings, over half have been presented. Important bequests of collections of pictures have included those of Holwell Carr in 1831, Wynn Ellis in 1876 and, in more recent years, George Salting (1910), Sir Austen Henry Layard (1916), Sir Hugh Lane (1917) and Ludwig Mond (1924). Pictures have been purchased independently from as early as 1825 when Correggio's *Madonna of the Basket* was bought from a dealer, and this painting, together with other early acquisitions, was bought with money granted specifically by the Treasury. From 1855 the Gallery has received from Parliament an annual purchase grant, which in those first years was £10,000 and to-day is almost £1m. In the 19th century it was not unusual (to-day it is more so) for the Gallery to purchase pictures at auction in the London salerooms and contemporary accounts describe scenes of enthusiastic

excitement whenever a picture was knocked down to the Gallery. The first Director also travelled annually in Europe in search of suitable pictures, and it was by this method that many of the Gallery's outstanding collection of early Italian pictures were acquired. To-day many of the Gallery's acquisitions are important pictures which have long been in British private collections, and which owners, invariably through taxation, now choose to sell. In such cases the Gallery sees it as its duty to retain such pictures if at all possible in this country, but in this it is not always successful. Current legislation however makes the sale of works of art by private treaty to national museums attractive to potential sellers, as such transactions are exempt from all taxes; and since 1972 legacies and gifts to the National Gallery of all property, not merely pictures, are exempt from estate duty. These arrangements which benefit both donors and the Gallery, have resulted in the acquisition of important paintings by Velázquez and Rembrandt.

The National Gallery is rare among the museums of the world in that every one of its paintings is fully described and discussed in the series of catalogues which have been published since 1945. These catalogues are compiled, and periodically revised, by the keeper staff, each of whom is given responsibility for a different part of the collection; and it is from these catalogues that much of the information contained in this *Guide* has been wilfully plagiarised.

The Gallery's policy is now to make its collection more accessible and more easily appreciable by the public. All the pictures are on permanent exhibition (excepting those which are lent to regional museums and to temporary exhibitions), while several times a year special exhibitions are held in the Gallery which serve to explain or highlight different aspects of the collection. Information 'bats' in each of the rooms introduce the pictures in those rooms. An Education Department has been established and lectures are given almost daily (as indeed they were in the 19th century), while audio visual methods are being developed, so that the Gallery may serve its public better. Response to these developments, and the Gallery's continued expansion, show that contrary to Lord Farnborough's fears in 1824 the British public has had little difficulty 'in attaining a taste for the liberal arts'.

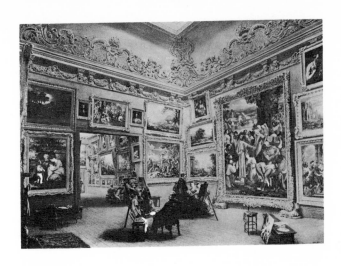

1 F. MacKenzie (*c.* 1787-1854) *The Gallery at 100 Pall Mall*

Watercolour

Victoria and Albert Museum

In its early years the National Gallery was situated at 100 Pall Mall, the former town house of John Julius Angerstein whose collection of pictures was purchased by the Treasury in 1824 to form the new National Gallery. Included in this view is Titian's *Bacchus and Ariadne*, Sebastiano del Piombo's *Raising of Lazarus*, several Claudes and a landscape by Cuyp.

2 The National Gallery, Trafalgar Square, London
Photograph: John Donat

This is the main façade of the Gallery which dominates Trafalgar Square from the north side. It was designed by William Wilkins (1778-1839) and the building was opened to the public in 1838. One of the provisos of Wilkins's commission was that he was to make use of the columns from demolished Carlton House; in fact the columns were found to be in such a state of decay that only the bases and capitals could be used, and they only for the 'pavilions'. This proviso probably accounts for the architect's curious use of a different order for the capitals of the columns and those of the pilasters.

3 Historical ground-plan of the National Gallery

This plan shows how and when the building has been enlarged. The original site upon which Wilkins erected his building was long and narrow, and it is only in subsequent years that sites have been cleared to the north of the original building making room for extensions to the Gallery.

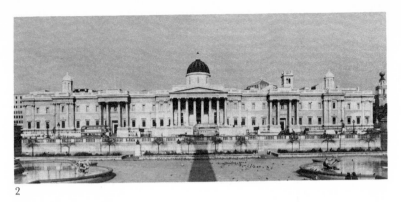

2

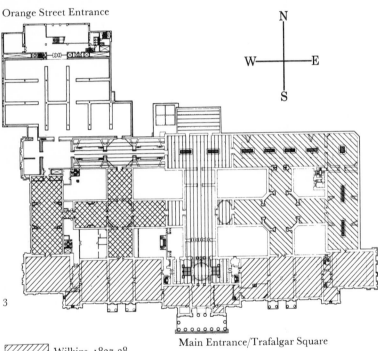

Orange Street Entrance

N
W———E
S

3

Main Entrance/Trafalgar Square

Wilkins 1837-38
E. M. Barry 1872-76
Taylor 1884-87
? Russell Pope 1927-28
Office of Works 1907-11
Dept of Environment 1973-75

4 G. B. Pittoni (1687-1767) *The Nativity with God the Father and the Holy Ghost*

$87\frac{1}{2} \times 60\frac{1}{2}$

Photograph taken during restoration

In early years the cleaning of pictures in the Gallery was often undertaken by the Keeper or by outside restorers. To-day the National Gallery has its own Conservation Department. This picture was purchased in 1958, and when subsequently cleaned at the Gallery, it was discovered that the figure of God the Father had been painted over, probably some time in the 19th century.

5 Bernard Partridge (1861-1945) Cartoon from *Punch*, '*Hans across the Sea*'

In 1909 Holbein's *Christina of Denmark* (fig. 37) was sold by the English family who had owned it from the 16th century. The National Gallery had insufficient funds with which to purchase it, and its possible export to America is the subject of this cartoon. A public appeal in fact secured the picture for the Gallery. The Duchess's plight in 1909 is one which still occupies the Gallery to-day, and most of its major acquisitions save pictures, long in British private collections, from export. Titian's *Death of Actaeon* (fig. 53) was purchased in 1972, but only after a public appeal (and substantial Government subsidy) had raised sufficient money to buy it.

6 A picture acquired for the Nation

In 1969 Tiepolo's *Allegory* (fig. 116) was sold at auction in London and purchased by the National Gallery. In the 19th century it was not uncommon for the Gallery to bid at auctions, when its purchases were usually greeted by the audience with enthusiastic applause. To-day it is rarer for the National Gallery to buy in the saleroom, and most of its purchases are made by private treaty either with owners or dealers.

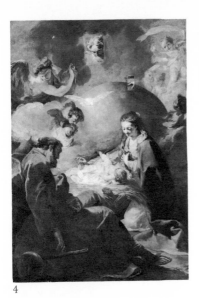

4

6

5

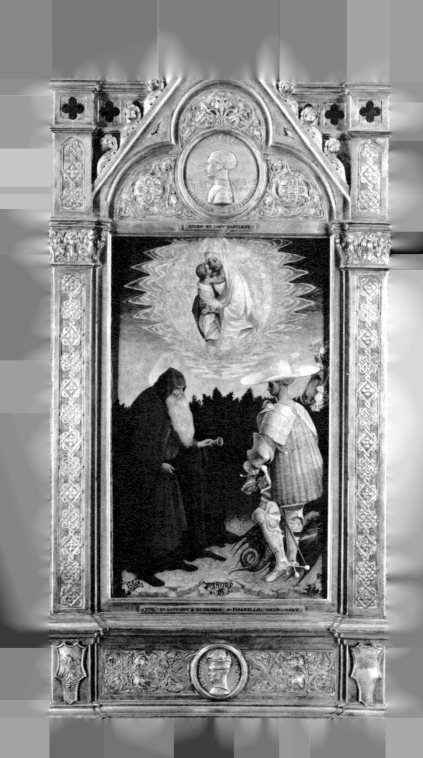

GIVEN BY LADY EASTLAKE.

*776. ST. ANTHONY & ST. GEORGE, BY PISANELLO: 1397/8-1455/6.

2 The Early Italian Schools

Pisanello (d. 1455?) *The Virgin and Child with Ss. George and Anthony Abbot*

$18\frac{1}{2} \times 11\frac{1}{2}$

Signed: *pisanus/pĩ*

The picture was presented in 1867 by Lady Eastlake in memory of her husband Sir Charles Eastlake who was the first Director of the Gallery. With its subject matter of S. George and enshrined in an absurdly gorgeous Victorian frame, no more suitable memorial could have been found to commemorate a great 19th century director of an English National Gallery.

Until 1855 and the appointment of Sir Charles Eastlake as the first Director, the National Gallery's acquisition policy, such as it was, was limited, in the words of an early Trustee 'to obtaining the best works of any considerable master'; and by the mid-century the Collection was rich in the work of artists such as Rubens, Rembrandt, Claude, Raphael, Correggio etc. Eastlake sought to develop the collection on a more historical basis, and in that he pioneered a taste in this country for Italian painters prior to Raphael. In the ten years of his directorship he purchased works by Piero della Francesca, Mantegna, Crivelli, Uccello, Duccio and others, and thus laid the basis for the Gallery's claim to be one of the most truly representative picture galleries in the world. Important bequests of early Italian pictures have been those of George Salting in 1910, Sir Henry Austen Layard in 1916 and Ludwig Mond in 1924.

The paintings of Duccio, who worked at Siena, are among the earliest pictures in the Gallery. These early 14th-century pictures, particularly those which represent the *Virgin and Child*, still retain much that is Byzantine in style, while the predella panels from the artist's major altarpiece, *The Maestà* (fig. 8) show the painter to have been a master of narrative. Even a century later, Sienese artists painted in a style that was more 'Byzantine' than that of painters who worked in neighbouring Florence. Giovanni di Paolo's *S. John* (front cover) sets off into a landscape that is as fantastic as it is unreal, although the painted architecture in the pictures of another Sienese, Sassetta (fig. 18) shows him to be aware of the developments in understanding perspective that were taking place in contemporary Florence.

The Wilton Diptych (fig. 7), and later, paintings by Pisanello are painted in the decorative courtly style, known as 'International Gothic', which found favour in northern Italy, France, Burgundy and Germany in the early years of the 15th century.

The Florentine, Giotto, is generally regarded as the founder of modern painting. A comparison of the *Pentecost* attributed to him with Sienese pictures in the Gallery show him to be breaking with the Byzantine tradition in favour of a more naturalistic vision. It is this concern with a more 'realistic' view of man and nature which occupied the artists of the Italian Renaissance, a

Room 1

Room 1

Room 6

Room 6

Room 1
Room 12

Room 1

hundred years after Giotto; and it was in Florence more than in any other centre that artists, in pursuing a study of perspective, anatomy and light and shade, painted pictures which as the century progressed became more and more 'life-like'. One may trace this progression in the works of Masaccio, Uccello, Piero della Francesca (who trained in Florence), Filippo Lippi, the Pollaiuoli, Botticelli, etc.

The word Renaissance (or re-birth) refers to the revival of art under the influence of Antiquity, and in many of the Gallery's 15th-century Italian pictures references to Antiquity may readily be spotted. Subject matter was increasingly more often derived from classical texts; painted architecture was invariably classical; portraits, like those on Antique gems and coins, were painted in profile; depiction of the nude became more popular, allowing as it did on the one hand a study of anatomy, and on the other a reference to classical statuary. In the *Martyrdom of S. Sebastian* by the brothers Pollaiuoli (fig. 14) the foreground archers are front and rear views of two different poses while some of the paintings of Mantegna were painted in direct imitation of stone sculpture.

Room 4

Room 12

7 French (?) School, *c.* 1395 or later, *Richard II presented to the Virgin and Child by his patron saints* ('*The Wilton Diptych*')

Each panel, 18 × 11½

The meaning or use of the Diptych, as also its date or place of execution remains uncertain. It is referred to as *The Wilton Diptych* as it was for long in the collection of the Earls of Pembroke at Wilton House. The King and his saints are represented in an earthly landscape, the Virgin and angels, standing in a bed of flowers, in a heavenly one. The Christ Child leans forward possibly to bless the King, or alternatively He may gesture towards the banner held by an angel. The banner may be the contemporary flag of England, a crusading flag, or the banner of Christ's Resurrection. The angels are personal to Richard, as they wear his white hart badge (seen also on the outside of the Diptych). They also wear collars of broom-cods, which are associated with Charles VI of France, whose daughter Isabella, Richard married in 1396.

8 Duccio (active 1278, died 1319) *The Annunciation*

17 × 17¼

This panel, like THE TRANSFIGURATION and JESUS OPENING THE EYES OF A MAN BORN BLIND, is part of the predella from Duccio's masterwork, the high altarpiece of Siena Cathedral, called *The Maestà*—executed between 1308 and 1311. Duccio was the first great Sienese painter, as Giotto was the first great Florentine. Painted before the invention of artificial perspective, Duccio's picture conveys the narrative of the theme with a lucidity that was quite new in painting.

9 Masaccio (1401-1427/29) *The Virgin and Child*

53¼ × 28¾

Painted in 1426 for the church of the Carmine at Pisa, it is the central panel of a polyptych, referred to as the Pisa Polyptych which is the artist's only documented work. By comparing the painting with the neighbouring QUARATESI ALTARPIECE* by Gentile da Fabriano which was painted just a year earlier, Masaccio's claim to be (with Giotto) one of the founders of Italian Renaissance painting will be understood. Gentile's *Madonna* has the decorative charm that one associates with the International Gothic style; Masaccio's is more 'real'; and the fall of light and treatment of the draperies suggest a form that is solid and not just a decorative surface pattern.

* On loan to the Gallery from the collection of Her Majesty The Queen.

7A

7B

8

9

10 Uccello (*c.* 1397-1475) *S. George and the Dragon*
22¼ × 29¼

A wicked dragon would stay at a distance from a certain city, but only if he was allowed to eat regularly some of its inhabitants. In time the turn came for the King's beautiful daughter to be eaten alive, but S. George arrived on a magnificent white horse in time to save her. He wounded the dragon with his lance and then the Princess led the beast by her girdle back to the city. Other versions of the theme in the Gallery include those of

CRIVELLI and DOMENICHINO; but none rivals Uccello in his delightful 'fairy-tale' treatment of the story.

11 Uccello (*c.* 1397-1475) *The Battle of San Romano*
71½ × 126

The picture is one of three battle-pieces probably commissioned by the Medici family in Florence in the 1450's (the other two are in the Uffizi and the Louvre). The pictures represent the Battle of San Romano fought between the Florentines and the Sienese in 1432. The warrior on the white horse in the National Gallery picture, who so bravely rides into battle without armour, is the Florentine captain Niccolò da Tolentino. The youthful combatant behind him (also unarmed) remains unidentified. Uccello was primarily a decorative painter, but he became interested, sometimes with strange results, in the new discoveries of perspective which were being made in Florence. There is much skilfully plotted detail in this battle which seems to take place in a rose-bordered orangery.

12 Botticelli (*c.* 1445-1510) *Tondo: The Adoration of the Kings*
Diameter: 51½

It was not until about the 1850's that Botticelli was generally known in England. His linear style appealed to the Pre-Raphaelites, and later the Aesthetic Movement approved such evidence of sickliness and weariness as they detected in his figures, particularly the Madonnas. An early Botticelli, the

small rectangular ADORATION OF THE KINGS, was purchased by the National Gallery in 1857. The present picture is also an early work, and in this wonderfully lively pageant, with people and animals depicted in action, Botticelli's mastery as a draughtsman is revealed. The boy, in red hose and blue doublet, who turns to look at the spectator may be a self-portrait of the artist.

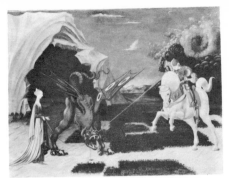

10

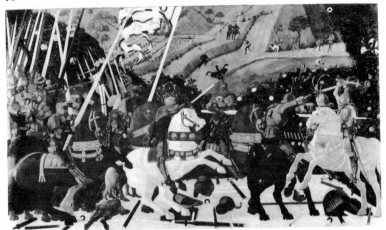

11

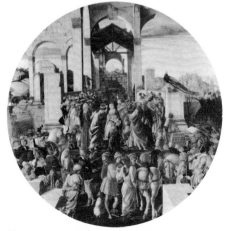

12

13 Botticelli (*c.* 1445-1510) *Mystic Nativity*

42¾ × 29½

In this late picture, signed with an inscription and probably dated 1500, Botticelli, in a quasi-medieval manner, distorts scale and perspective in the interest of his narrative: the Virgin is larger than any other figure and the foreground landscape is distorted. Such a treatment was unusual for an artist who worked in Renaissance Florence where study of perspective, anatomy, and light and shade had led artists to painting pictures in as 'life-like' a manner as possible. This *Mystic Nativity* is an emotional picture, as are the SCENES FROM THE LIFE OF S. ZENOBIUS, another late Botticelli in the Gallery; and it is sometimes suggested that in his later years Botticelli was influenced by the fervent piety of the Dominican preacher Savonarola, who was burned in Florence in 1498.

14 Ascribed to Antonio (*c.* 1432-1498) and Piero (*c.* 1441-*c.* 1496), del Pollaiuolo *The Martyrdom of S. Sebastian*

114¾ × 79¾

The artists were Florentine brothers who worked as sculptors, painters, engravers and goldsmiths. In the present picture the foreground archers are depicted in pairs of identical poses, like sculptures seen from the front and rear. In the precise definition of the straining muscles, the facial expressions of the archers, and the almost botanical treatment of the landscape, the brothers reveal an approach to their art that is scientific; and in that they foreshadow Leonardo da Vinci. The Christian theme of the *Martyrdom of S. Sebastian* was a popular one in the Renaissance, allowing as it did anatomical study in the treatment of the nude saint.*

15 Piero di Cosimo (*c.* 1462-after 1515) *A Mythological Subject*

25¾ × 72¼

The two mythological paintings in the Gallery by a witty Florentine artist, Piero di Cosimo, have a tremendous appeal. The FIGHT BETWEEN THE LAPITHS AND CENTAURS is packed with hilarious incident: the Lapith bride (foreground right) is having her hair pulled by a Centaur as a preliminary to rape—but wearing a dress like that, what else does she expect from a centaur? Piero loved animals and nature, and both are splendidly observed in the present picture.

* Other versions in the Gallery include those of CIMA, MATTEO DI GIOVANNI, ZAGANELLI, SIGNORELLI and L'ORTOLANO.

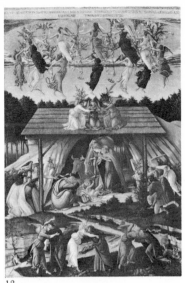

13

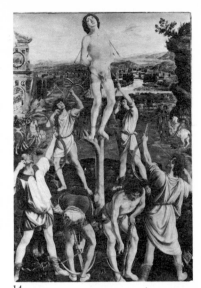

14

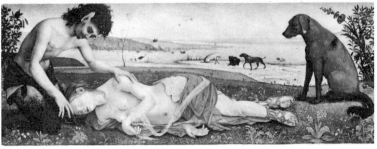

15

16 Piero della Francesca (active 1439-1492)
The Baptism of Christ

$66 \times 45\frac{3}{4}$

Probably painted soon after 1442 as the central panel of a triptych for the high altar of S. Giovanni Evangelista in Piero's home town of Borgo Sansepolcro, the *Baptism* includes a view of Sansepolcro in the background. The composition is based on a pattern of easily discernible verticals and horizontals, and depth is established by the diminishing scale of the figures: Christ in the foreground, the neophyte removing his shirt behind, and the figures in the background. The landscape, as reflected in the water, is closely observed, and the overall effect of the altarpiece is one of timelessness suggested by Piero's uniquely beautiful, cool and airy colouring. The painting was bought by the Gallery in 1861 when the artist was still relatively unknown and unappreciated.

17 Piero della Francesca (active 1439-1492)
The Nativity

$49 \times 48\frac{1}{4}$

The picture, which is possibly a late work by the artist, may be unfinished although areas of it, e.g. the shepherds, S. Joseph, and the dresses of the angels were probably over-cleaned before the picture was bought by the Gallery in 1874. All the parts of the painting seem isolated within the composition: the stable is isolated from the landscape, the Virgin isolated in adoring the Christ Child, the shepherds isolated in gesturing towards the Star and the musician angels (who are joined by a braying ass) isolated, like a choir brought along for the occasion. Piero bathes the scene in daylight, with a sharp shadow cast by the roof of the stable.

18 Sassetta (1392?-1450) *S. Francis decides to become a Soldier*

$34\frac{1}{4} \times 20\frac{5}{8}$

One of a series of seven panels in the Gallery from the high-altarpiece of the church of S. Francesco in Sansepolcro, which the Sienese artist delivered in 1444. S. Francis gives his clothes to a knight poorer than himself; is visited by an angel who brings him a dream of heavenly Jerusalem. By undressing, the saint renounces his rich earthly father, and later, with his disciples, is blessed by the Pope. He receives the stigmata, and as a test of his faith prepares to walk through fire. Thanks to him the savage wolf of Gubbio agrees to be fed at the public expense, while the last scene shows the funeral of the Saint.

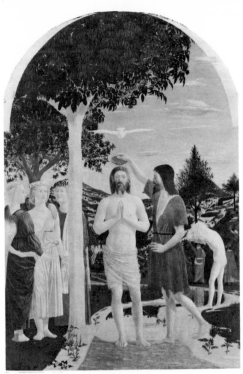

16

17

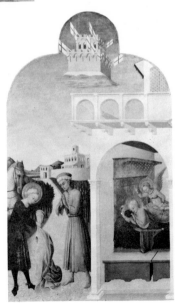

18

19 Giovanni Bellini (active *c.* 1459-1516) '*The Madonna of the Meadow*'

26½ × 34

Photographed from the back during restoration

This is a late work by the artist and is the most moving of the three Bellini Madonnas in the Gallery. The Virgin reflects in saddened prayer on the nude Christ Child whose pose is similar to that of a Dead Christ in a *Pietà*. In Bellini's picture He is therefore the Redeemer born to save sinners; and so plants flower with renewed vigour beside the Virgin. The picture was painted on panel but transferred to canvas in 1949, when the photograph reproduced here was taken from the back.

20 Giovanni Bellini (active *c.* 1459-1516) *The Doge Leonardo Loredan*

24¼ × 17¾

Signed: IOANNES BELLINVS

The sitter, who was about 65 when the portrait was painted, was Doge of Venice from 1501-1521. The form of the portrait is that of a sculpted bust resting on a parapet; and in this emulation of sculpture, Bellini reflects the contemporary work of his brother-in-law Mantegna whose *grisaille* paintings (fig. 23) appear like Antique marble reliefs. But Bellini's miraculously diffused lighting, and non-frontal pose, imbue the sitter with a quality which, far from being stone-like, is on the contrary extremely life-like.

21 Antonello da Messina (active 1456, died 1479) *S. Jerome in his study*

18 × 14¼

The painter is so called because he came from Messina in Sicily. His style was influenced by the paintings (which he probably saw in Naples) of Netherlandish artists such as Jan Van Eyck (q.v.) and Rogier van der Weyden (q.v.); an influence noticeable in the present picture, for instance, in the background windows which open unto detailed landscapes (see fig. 30). Antonello also worked in Venice. In this picture, which is presumed to be one of the artist's earliest works, a proscenium arch frames the scene of the saint seated in a 'doll's-house' study which has been set down in a gothic interior. The tiled floor, the arched colonnade and above all the light which penetrates the scene from front and rear create an effect which is fascinating by its very combination of detail.

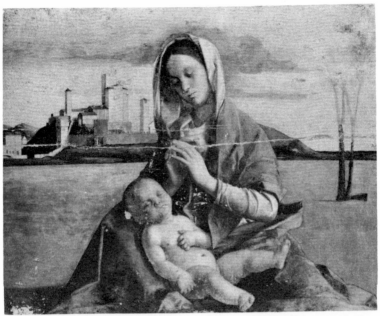

19

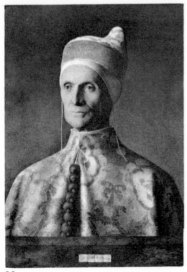

20

21

22 Mantegna (*c.* 1430/1-1506) *The Virgin and Child with the Magdalen and S. John The Baptist*

54¾ × 46

Signed: *Andreas Mantinia C.P.F.*

C.P. has been interpreted as *Cives Patavinus* (citizen of Padua) where Mantegna spent his early years. Ruskin advised '... (when looking at a Mantegna) ... give ten minutes (to it) quietly and examine it with a magnifying glass of considerable power. ...' Even without the use of a glass the visitor may easily appreciate the painter's extremely detailed technique. In this gloriously colourful altarpiece fruits and flowers burgeon in the background; the veins on the Baptist's arm are minutely observed, and each crease in the draperies is carefully depicted.

23 Mantegna (*c.* 1430/1-1506) *Samson and Delilah*

18½ × 14½

Inscribed: FOEMINA / DIABOLO TRIBVS / ASSIBVS EST / MALA PEIOR

Delilah having discovered that Sampson's strength lay in his hair, 'made him sleep upon her knees; and she called for a man, and she caused him to shave off the seven locks of his head ... and his strength went from him.' Mantegna departs from the biblical text by showing Delilah doing the deed herself, perhaps to illustrate all the more the proverb inscribed on the tree which means 'Woman is evil, a trifle worse than the devil'. But Mantegna's Delilah is a woman of tender compassion, and looking down on the slumped figure of Samson at her knees reminds us of the Virgin as she was depicted with her dead Son in any Renaissance *Pietà*. The painting is executed in *grisaille* in imitation of sculpture, a technique characteristic of the painter.

24 Crivelli (active 1457-1493) *The Annunciation with S. Emidius*

81½ × 57¾

Signed: OPVS. CARO / LI . CRIVELLI / VENETI and dated . 1486

The angel Gabriel is attempting to perform the Annunciation, but is waylaid by S. Emidius who carries a model of the town of Ascoli of which he was patron saint. The picture commemorates a papal grant to the town which was celebrated each year on the Feast of the Annunciation. Crivelli was a Venetian painter living in Ascoli and the present picture, perhaps his masterpiece, is a tour-de-force of painted perspective, decoration and effect: the inhabitants are unheeding of the event taking place in their town. Characteristically for the painter the picture is crowded with symbols, most obviously the apple and gourd, the peacock, the goldfinch in its cage, the lighted candle etc.

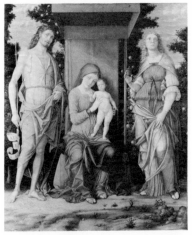

22

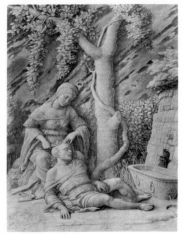

23

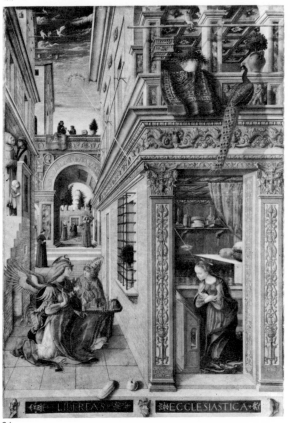

24

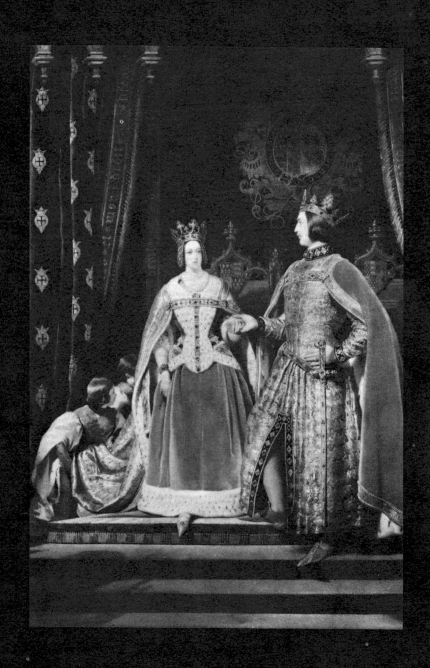

3 The Early Netherlandish and German Schools

Sir Edwin Landseer (1802-1873) *Queen Victoria and Prince Albert in pseudo 14th-century costume as Edward III and Queen Philippa*

By gracious permission of Her Majesty the Queen

Although Prince Albert had no official connections with the National Gallery he was a friend of the first Director, Sir Charles Eastlake; and, together with Eastlake was among those who pioneered an interest in the painting of the 'Primitives' in this country. He himself collected (many of the pictures he bought were, like himself, German) and he encouraged the Queen to present a number of important early Italian, Netherlandish and German pictures to the Gallery in 1863.

Room 23

Room 23

Room 24
Room 24

Van Eyck's celebrated ARNOLFINI MARRIAGE (fig 26), had only been in England for less than thirty years at the time of its acquisition by the Gallery in 1842. The same artist's MAN IN A TURBAN (bought in 1851) had been in this country from the 17th century. The first group of Early Netherlandish and German pictures acquired by the Gallery came in 1854 with the purchase of the Krüger collection from Germany—a private collection of predominantly Early German pictures. The Prince Consort, a friend of the first Director of the Gallery, did much to establish a taste for Northern 'Primitives' in this country and in 1863 he persuaded Queen Victoria to present a group of paintings, Netherlandish, German and Italian to the Gallery. Holbein's AMBASSADORS and CHRISTINA had long been in British private collections before they came to the Gallery in 1890 and 1909 respectively.

The term Netherlandish refers to those countries which are now called Holland and Belgium, but which in the 15th century comprised a number of small states. It was in the cities which we still know to-day, Bruges, Brussels etc, that the early Netherlandish artists worked; and one of the earliest of these, Jan van Eyck (who worked in Bruges) is known to have played a seminal role in the discovery of oil-painting technique. Van Eyck's contemporary, Robert Campin, worked at Tournai and was the teacher of the most influential of 15th-century Netherlandish painters, Rogier van der Weyden. Rogier, who exerted an influence on Bouts and Memlinc, was the most important artist working at Bruges and was succeeded upon his death by Gerard David.

The term 'German' is used to refer to the countries which we now know as Germany, Austria and Switzerland. Stephen Lochner worked in Cologne, Michael Pacher was Austrian and Lucas Cranach worked at Wittenberg. Two of the most famous painters of the Renaissance, Dürer and Holbein, were both German.

Renaissance painting in Northern Europe is characterised by its meticulous and exact depiction of surface detail. Light is also important, and in many of the Gallery's Early Netherlandish paintings, bright light penetrates from 'outside' to highlight details of the interior scene which is the subject of the picture. In religious paintings the outside view, invariably seen through a window or an

arch, is intended to represent an earthly world, whereas the room in which the Madonna may be enthroned is a heavenly one.

In contrast to the early paintings of the Italian Renaissance, the influence of the Antique is scarcely perceptible in early Netherlandish painting; and many pictures have a domestic quality unlike the often, almost pagan character of Italian paintings of the same period. Figures are well-clothed in heavy garments (it was much colder in Northern Europe), the folds of which fall in patterns, illuminated by an almost 'heavenly' light. Nudity or near nudity is almost unknown. Saints and martyrs in Italian Renaissance painting hold the attributes by which we recognise them, and of course they also do in Northern painting; but the Northerners carried a love of symbol much further and the spectator may be content that most of the domestic detail which is represented in the paintings of Van Eyck, Campin, Rogier etc. has a symbolic significance. As in Italy, portraiture was developed in the period, and it was less unusual for the Northern artist to discreetly include his own self-portrait in some religious scene.

25 Jan van Eyck (active 1422, died 1441) *Portrait of a Young Man*

$13\frac{1}{8} \times 7\frac{1}{2}$

Signed: *Actu ano dni . 1432 10. die octobris . a . ioh de Eyck*

This portrait, with its decaying parapet and a distant expression in the features of the sitter, is in contrast to the other, extremely life-like portrait of A MAN IN A TURBAN by Van Eyck. The portrait is possibly commemorative: *Leal Souvenir* means something like *True Remembrance* and the Greek inscription 'Tymotheus' may refer to a famous Greek musician of the 4th century B.C., thus suggesting that the man in the portrait was a musician.

26 Jan van Eyck (active 1422—died 1441) *'The Arnolfini Marriage'*

$32\frac{1}{4} \times 23\frac{1}{2}$

Signed: *Johannes de eyck fuit hic. | . 1434*

The bridegroom was an Italian living in Bruges where Van Eyck was working in the service of the Duke of Burgundy. Painted in 1434, at a time when a couple might contract a marriage simply with appropriate words and actions, the picture shows the couple holding hands; she wears a ring and he gestures as if taking an oath. The single burning candle in the chandelier, symbol of the all-seeing wisdom of God, is a 'marriage candle'; the carved figure on the back of the chair is S. Margaret, a saint associated with brides, and invoked by pregnant women. The griffon terrier in the foreground may be associated with *Fidelity*. The entire scene is reflected in the convex mirror on the back wall, and in that mirror, between the reversed figures of the Arnolfini, stands a figure, presumably Van Eyck. Hence the inscription 'Jan van Eyck was here'.

27 Dieric Bouts (living *c.* 1448, died 1475) *The Virgin and Child*

$14\frac{5}{8} \times 10\frac{7}{8}$

In an interior, and before a once-folded and richly brocaded cloth of honour, the Virgin suckles the Christ Child. As always in 15th-century Netherlandish paintings the material of the cloth of honour is a contemporary and possibly identifiable fabric. He is seated on a cushion placed on a ledge. Bouts worked at Louvain and his style is strongly influenced by Rogier van der Weyden (q.v.).

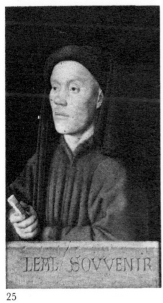

25

26

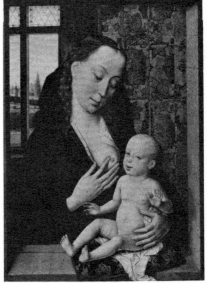

27

28 Gerard David (active 1484, died 1523) *The Virgin and Child with Saints and Donor*

$41\frac{3}{4} \times 56\frac{3}{4}$

The Virgin and Child are enthroned within a walled garden, the *Hortus Conclusus* (a garden close-locked) which alludes to the Virgin's virginity. The saints are, from left to right, S. Catherine (her wheel by the pillar behind), S. Barbara (with an ornament in the form of a tower on her forehead) and the Magdalen (holding a jar). S. Anthony Abbott stands in the background, also an angel gathering grapes. The altarpiece is thought to have come from the chapel of S. Anthony in S. Donatian's at Bruges, and the donor (who would have presented the altarpiece), and who was cantor of S. Donatian's, is probably Richardus de Capella who is depicted in the picture. His arms are on the collar of the dog, and his cantor's staff is on the ground beside him.

29 Robert Campin (1378/9-1444) *The Virgin and Child before a Firescreen*

$25 \times 19\frac{1}{2}$

The Madonna is characterised as a homely nursing mother in a domestic interior with a view through the window of a busy town. The firescreen serves as a natural halo. By his observation of such details as the book cover (the drapery underneath the Virgin's book) which is 'contemporary' and the scene of daily life, the artist also makes the Virgin contemporary. This more realistic treatment of a religious theme is characteristic of the artist who worked at Tournai.

30 Rogier van der Weyden (*c.* 1399-1464) *S. Ivo* (*?*)

$17\frac{3}{4} \times 13\frac{3}{4}$

The artist was the most important painter working in Flanders in the mid-15th century. He was probably a pupil of Robert Campin (q.v.) at Tournai but in the early 1430's moved to Brussels. His art is more 'human' than that of the earlier Jan van Eyck, and he excelled at portraiture. Thus this picture has a portrait air, with the man's face observed down to the detail of the blemish at his mouth. Yet it is by no means certain that this is a portrait and the picture may possibly represent S. Ivo who was the patron of lawyers. He is absorbed in reading an undecipherable letter in an upstairs room with the typical Netherlandish view of a landscape seen through a window.

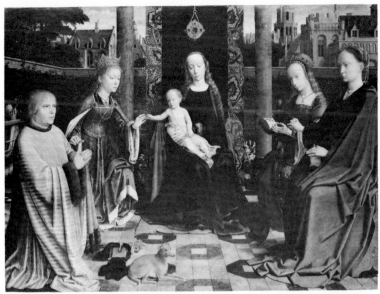

28

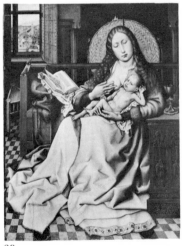

29

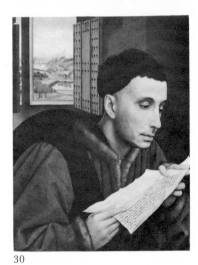

30

31 Memlinc (active 1465, died 1494) *The Virgin and Child with Saints and Donors ('The Donne Triptych')*

Central part: 27⅞ × 27¾; wings: 28 × 12

The artist, born in Germany, may have been a pupil of Rogier Van der Weyden and later became the most successful artist working in Bruges. The picture was commissioned in Bruges by an Englishman, Sir John Donne whose portrait together with that of his wife is included in the central panel. Probably painted some time in the late 1470's the picture contains many of the elements observable in the earlier paintings of Bouts, Campin and Rogier van der Weyden. The Virgin is seated under a canopy with a richly brocaded cloth of honour in a 'heavenly' interior; the 'earthly' landscape, brightly illuminated, is seen through apertures in the background. The pose of the Christ Child in benediction is also found in earlier paintings, and the whole is minutely and lucidly observed. The figure 'outside' in the left wing may be a self-portrait of the artist.

32 Pieter Bruegel the Elder (active 1551, died 1569) *The Adoration of the Magi*

43¾ × 32¾

Signed: BRVEGEL M.D. LXiiii

The artist, who was active chiefly at Antwerp and who is sometimes referred to as 'Peasant Bruegel' is known by all for his satirical scenes of village life and his much reproduced series of the *Months of the Year*. Far from being a peasant himself, he was in fact highly cultivated. The narrative element, which is so important a part of his best known work, also plays a part in the present picture: a man whispers in the ear of S. Joseph in the background, the Virgin and Child gesture etc., and the Magi are depicted not without satire. The picture is influenced by Bruegel's satiric predecessor, Hieronymous Bosch: the arrow through the hat of the man in the background appears also in CHRIST MOCKED by Bosch.

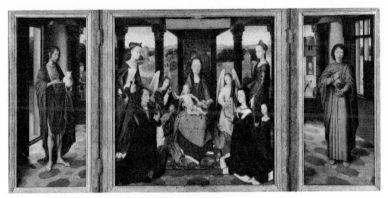

31

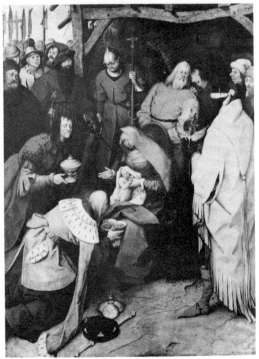

32

33 Jan Gossaert, called Mabuse (active 1503, died 1532) *The Adoration of the Kings*
$69\frac{3}{4} \times 63\frac{1}{2}$

Signed: (on Balthazar's crown): IENNI / GOSSART, also (on his follower's collar): IENNI / GOS()

The sumptuous setting of the scene which is shown taking place in a magnificent ruin, as was usual in Gossaert's time, contrasts with Bruegel's treatment of the same subject of some sixty years later. The nine angels represent the heavenly hierarchy; the column in the background, which appears frequently in Netherlandish paintings of the *Nativity*, may be associated with the column on which the Virgin was said to have supported herself at the birth, or alternatively it may be the column of the *Flagellation*; the figure behind the ox (left of the Virgin) may be a self-portrait of the artist, which would not be unusual in Netherlandish painting. The picture, which is the artist's most important early work, was recently cleaned to reveal the full splendour of the detailing and colouring.

34 Stephan Lochner (active 1442—died 1451)
Ss. Matthew, Catherine of Alexandria and John the Evangelist
$27 \times 22\frac{7}{8}$

The picture, which is also painted on the *verso*, is the left wing of an altarpiece, the right wing of which is in the Wallraf-Richartz Museum, Cologne. S. Matthew is shown with book and angel; S. Catherine with the fragmentary remains of her wheel of martyrdom; and the Evangelist with a haloed eagle and chalice and serpent. The latter attribute, which is traditional, alludes to S. John's faith being tested by his being asked to drink from a poisoned cup, which he did and survived. Lochner worked at Cologne which throughout the 15th century was a prosperous trading centre.

33

34

35 Cranach (1472-1553) *Cupid complaining to Venus*
32 × 21½

Signed, on the stone bottom right with Cranach's device of a winged snake

The picture is of a type of erotic full-length female nude, for which the artist is perhaps most famous. They are variously called *Charity*, *Eve*, *Venus* or the *Three Graces*; in the present picture, where she is tearfully offered a honeycomb by her son Cupid, who has been stung while stealing it, she seems to be Venus; but as she also reaches above her to the apples on the tree, she coyly suggests to us that she might well be Eve. Cranach was also an outstanding portraitist and worked at Wittenberg as Court Painter to the Electors of Saxony.

36 Ascribed to Dürer (1471-1528) *The Painter's Father*
20 1/16 × 15 7/8

Inscribed at the top: 1497 . ALBRECHT . THVRER . DER . ELTER . VND. ALT. 70 IOR

The sitter, Albrecht Dürer the Elder, was a goldsmith who taught his son his craft. The present picture is the best of several versions of the picture which survive, but even still it is not accepted by all scholars as having been painted by Dürer. It is likely that the picture was presented by the citizens of Dürer's native Nuremberg to Charles I of England in 1636, when it was believed to be by Dürer. Dürer, the greatest artist of the German School, produced an enormous oeuvre, consisting of drawings, paintings, woodcuts and engravings. He also wrote treatises on Measurement, Fortification, Proportion and Artistic Theory.

37 Hans Holbein the Younger (1497/98-1543)
Christina of Denmark, Duchess of Milan
70½ × 32½

Holbein was a German painter who for the later part of his life worked in England, and to whom we owe our image of Henry VIII and his Court, in whose service he was employed. From England he travelled on the Continent and made portraits of possible brides of the King, and this outstanding portrait is such a picture. Christina (1522-1590) was the daughter of Christian II of Denmark and widow of the Duke of Milan, (in the portrait she wears mourning). On March 12th, 1538, she sat to Holbein at Brussels for 'thre owers space' when the painter recorded her image, and from that image he evolved the present portrait. Christina, who probably never saw the picture, never of course married Henry (fortunately for herself), but later married the Duc de Lorraine.

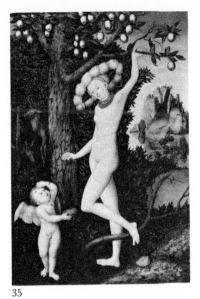

35

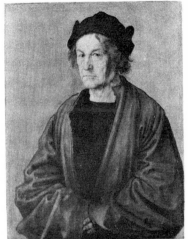

36

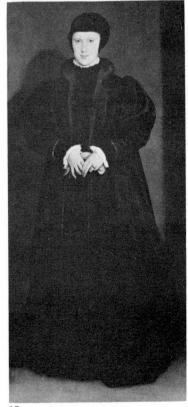

37

38 Hans Holbein the Younger (1497/98-1543)
'The Ambassadors'

$81\frac{1}{2} \times 82\frac{1}{2}$

Inscribed: IOANNES / HOLBEIN / PINGEBAT / 1533

The portrait represents, on the left, Jean de Dinteville (1504-1555), French Ambassador to England from mid-February to mid-November 1533, whose age, 29, is given on the sheath of his dagger. The other figure is his friend Georges de Selve (1508/9-1541), Bishop of Lavaur, who visited Dinteville in London in April 1533. His age, 25, is inscribed on the book underneath his elbow. The cylindrical dial on the whatnot gives the date as April 11th, the polyhedral dial (right) gives the time, 10.30 a.m. The curious shape across the foreground of the picture, which assumes the form of a skull when viewed from the right of the painting; the skull brooch on Dinteville's cap; the Crucifix (top left); and the broken lute string serve as reminders of mortality, and strike a chill note in a portrait which otherwise depicts two accomplished and successful young men.

39 Bartholomaeus Spranger (1546-1611)
The Adoration of the Magi

$78\frac{5}{8} \times 56\frac{1}{2}$

Signed: B / SPRANGERS, ANT.VSS. / C. M,TIS A CUBI. LOPICTOR / F

The signature means 'B. Sprangers (*sic*) of Antwerp, painter from the studio of His Majesty the Holy Emperor'. The scene is the traditional one with the oldest Magus, Caspar, kneeling before the infant Christ and presenting gold to Him as homage to His kingship. Balthazar, a negro, and the youngest, Melchior, present frankincense as homage to His divinity and myrrh (used in embalming), foreshadowing Christ's death. The theme was a popular one in the 15th and 16th centuries, when princes and kings saw themselves mirrored by the Magi who were invariably dressed in contemporary court fashions. Spranger's version is more sumptuous than most, and reflects the elegance of the Emperor Rudolf II's court in Prague where Spranger was employed and where the picture was probably painted some time in the 1590's.

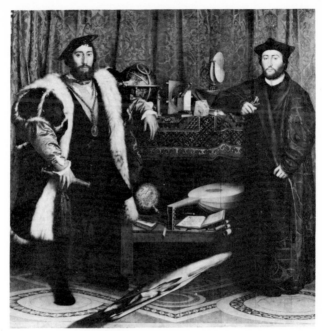

38

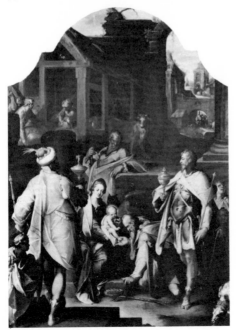

39

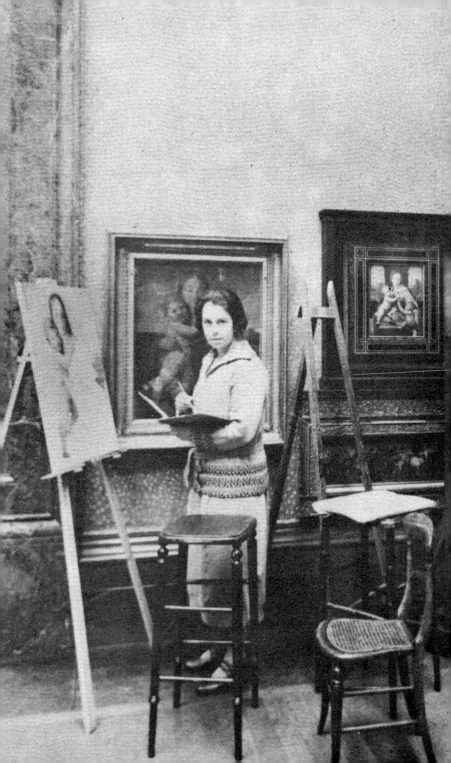

4 The Sixteenth and Seventeenth Century Italian Schools

Copying Raphaels in 1928

The Raphaels are left, *The Mackintosh Madonna*, right *Madonna and Child with S. John* and underneath is *The Procession to Calvary*.

Many of the Gallery's outstanding collection of 16th-century Italian pictures were acquired both by purchase and gift during the first decades of its existence. However, purchases where possible still continue to be made and the Leonardo CARTOON (fig. 40) was bought in 1962; Titian's DEATH OF ACTAEON (fig. 53) in 1972 and Parmigianino's MYSTIC MARRIAGE OF S. CATHERINE in 1975. All of these pictures had long been in British private collections.

Room 7
Room 9
Room 8

The three great artists of the Italian High Renaissance, Leonardo, Michelangelo and Raphael are all represented in the Gallery, although of the nine Raphaels in the collection none are late works. The oldest of this trio was Leonardo, who worked in Milan in the last decades of the 15th century; and it was for the Church of S. Francesco Grande there that the VIRGIN OF THE ROCKS was painted. The commission was given in 1483 but by 1508 the picture was still unfinished; it remained unfinished. Although paintings by Leonardo are rare, the authenticity of the painting is not challenged by the fact that another similar though earlier variant of this composition exists, and is now in the Louvre. The opinion of scholars remains divided in explaining the origin of the two versions of the picture. In the early years of the 16th century Leonardo moved to Florence. There both he and Michelangelo, who was also Florentine, exerted an influence on the young Raphael, and indeed Leonardo's work influenced, to an extent, almost all painting in northern Italy in the first decades of the 16th century.

Room 14

Within the first decade of the century Raphael and Michelangelo left Florence for Rome, and were there employed in painting in the Vatican for the Pope, JULIUS II (fig. 43). With their departure, and Leonardo's return to Milan in 1506, the importance of Florence as an artistic centre declined, although the Florentine traditions were carried on by Andrea del Sarto, his pupil Pontormo and the latter's pupil Bronzino.

Room 8

Room 8

Vasari said that Giorgione was the Leonardo of Venice, in that he was an innovator and the creator of a new style. His work influenced the later work of Giovanni Bellini, and also that of the young Titian. The Gallery is particularly rich in the work of Titian with early and late religious works, mythologies and portraits: the HOLY FAMILY (Cat. no. 4) and the MADONNA AND CHILD (Cat. no. 3948): BACCHUS AND ARIADNE (fig. 52) and THE DEATH OF

Room 10

Room 9
Room 9
Room 9

ACTAEON (fig. 53); LA SCHIAVONA (Cat. no. 5385) and the
ALLEGORY OF PRUDENCE (fig. 50). Titian's great Venetian
successors were Tintoretto and Veronese. The latter
created a world on canvas that suggests the splendour of
16th-century Venice: a world inhabited contemporaneously, and with equal magnificence, by the MAGI (Cat.
no. 268), the MAGDALEN (Cat. no. 931), S. NICHOLAS (Cat.
no. 26) and ALEXANDER THE GREAT (fig. 55); while S.
HELENA (Cat. No. 1041), supposedly dreaming of the
True Cross, is more probably a courtesan idly bleaching
her hair on a Venetian roof terrace.

The Gallery is less rich in paintings of the Italian 17th
century than it is in other Schools; and whereas other
collections generally boast a room of enormous 17th-
century Italian canvases, the National Gallery's collection
consists chiefly of a group of small but choice works by
the Carracci and their school, a series of frescoes by
Domenichino and a distinguished Caravaggio.

The Carracci founded a famous painting Academy in
Bologna in the 1580's and in this Academy, where the
teaching was based largely on a revaluation of the ideals
of the High Renaissance, the young Guido Reni,
Domenichino and Guercino received some training.
Later, these artists moved to Rome, where in the first de-
cade of the century their style seemed to be challenged by
that of Caravaggio, whose revolutionary paintings de-
pended largely on directly observed nature. Caravaggio's
lighting effects were also to influence later painters, not
only in Italy but throughout Europe. The 17th-century
Neapolitan School is represented by Ribera, the Spanish
painter who settled at Naples about 1616, Mattia Preti,
Salvator Rosa and, slightly later, Solimena.

Room 9
Room 9

Room 9
Room 9
Room 9
Room 9

Rooms 31,29

Room 29

Room 7 **40** Leonardo da Vinci (1452-1519) *The Virgin and Child with S. Anne and S. John the Baptist.*

51¾ × 41

Room 14
Room 7

Both Leonardos in the Gallery show the artist composing a group of two adults and two children within a pyramidical shape. The haunting shadows, the gracefully turning bodies and the mysterious smiles of the Virgin and the angel in the MADONNA OF THE ROCKS are all intensified in the later monochrome CARTOON of the Virgin with her mother S. Anne, the Christ Child and S. John the Baptist. In the one she kneels in a strange grotto amid minutely observed flowers, and, protecting the Baptist with one hand, indicates the importance of the Christ Child with the other. In the *Cartoon* the relationships between the figures are more curious as they gaze from one to another, their bodies almost merged in one.

Room 8

41 Michelangelo (1475-1564) *The Entombment* (unfinished)

63⅔ × 59

Being also a sculptor, Michelangelo treats the painting of *The Entombment* in a strongly sculptural way, and indeed the composition was influenced by the famous Antique marble group, *The Laocoön*, discovered in Rome in 1506 (the year in which this picture seems to have been partly painted). The artist is interested in the tensions produced in the bodies of the figures as they lift the dead weight of Christ. This is particularly noticeable in the case of Nicodemus (in the red robe) whose neck, arm and leg muscles strain as he pulls Christ's dressings taut across his knee.

Room 8

42 Raphael (1483-1520) '*The Ansidei Madonna*'

82½ × 58½

Dated probably MDV on the hem of the Madonna's dress

Room 8

Painted for the Ansidei family chapel in the Church of S. Fiorenzo at Perugia, and completed after the artist's first visit to Florence, the altarpiece should be compared to the earlier Raphael altarpiece in the Gallery, 'THE MOND CRUCIFIXION'. This latter reflects the influence of the painter's teacher Perugino, but in the present picture the expressions of the figures assume more meaning, and the composition is more complex. The throne is elaborately architectural, and the use of light and cast-shadows highly sophisticated. The Umbrian landscape, so prominent in the *Mond* altarpiece, is here only to be glimpsed on either side of the throne.

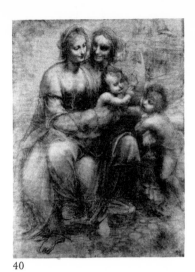

40

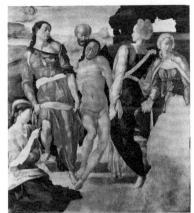

41

42

43 Raphael (1483-1520) *Pope Julius II*
42½ × 31¾

Datable 1511-1512 on the evidence of the Pope's beard (which he only wore in those years), the picture was regarded by contemporaries as the most celebrated of Raphael's portraits. The pose of the Pope, three-quarter length, seated in an arm-chair and seen from an angle became the prototype for countless similar portraits by later painters.* The Pope was the first great patron of Michelangelo (commissioning from him a tomb for himself and the ceiling decoration of the Sistine Chapel). He also employed Raphael to decorate the celebrated *Stanze* in the Vatican.

44 Bronzino (1503-1572) *An Allegory*
57½ × 45¾

Cupid (Love) beguiled by the kiss of Venus (Beauty) is simultaneously disarmed by her; and, unknown to him, she holds aloft the arrow from his quiver. Folly, to the right, prepares to shower the couple with roses. Winged and aged Time (top right) attempts to destroy the hollow mask that is Fraud (top left) and below Jealousy tears her hair in anguish. The girl behind Folly is Pleasure, and, proferring a honeycomb in one hand and the sting from her tail in the other, demonstrates that the sweetness which she brings may also be accompanied by pain.

45 Sebastiano del Piombo (*c.* 1485-1547) *The Raising of Lazarus*
c. 150 × 114

Signed: SEBASTIANVS . VENETVS . FACIE/BAT

The artist was the protegé of Michelangelo and the picture was painted in Rome between 1517 and 1519 in competition with Raphael whose contribution was the *Transfiguration* now in the Vatican. Drawings by Michelangelo in the British Museum and elsewhere for parts of the composition confirm Vasari's statement that Sebastiano was assisted by Michelangelo with the picture. Hazlitt found the flesh of Lazarus 'well-baked dingy, and ready to crumble from the touch . . . as it is liberated from its dread confinement'.

* Cf. CARDINAL CERRI by J. F. Voet and the PORTRAIT OF A CARDINAL by Scipione Pulzone.

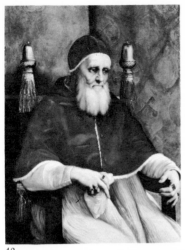

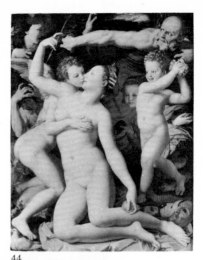

43 44

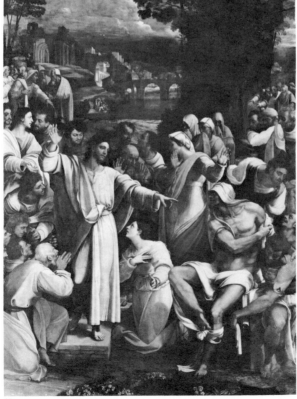

45

Room 8 **46** Correggio (d. 1534) *The Madonna of the Basket*

$13\frac{1}{4} \times 9\frac{7}{8}$

This small picture, although probably painted in the 1520's, is almost 18th century in its prettiness and gracefulness. The scene has a domestic quality with the carpenter S. Joseph at work in the background and the Madonna, who is scarcely more than a girl, constraining a wilful Christ Child as He struggles on her knees. His gesture of benediction with His right hand seems almost accidental.

Room 8 **47** X-ray photograph of Correggio (d. 1534) '*The School of Love*'

$61\frac{1}{4} \times 36$

Cupid, so often the tutor of others in the ways of love is here brought by his mother Venus to be instructed in reading by Mercury. X-ray photographs reveal that Correggio originally painted the faces of Mercury and Venus in different positions.

Room 8 **48** Parmigianino (1503-1540) *Altarpiece*

$135 \times 58\frac{1}{2}$

S. John the Baptist directs the attention of the spectator towards the Madonna and Child above. The presence of S. Jerome asleep in the background has led to the picture being erroneously called a *Vision of S. Jerome*; but there is no evidence to suggest that S. Jerome ever had such a vision. It was painted in Rome in 1527 during the Sack of the city by German troops, who, discovering Parmigianino at work, left him unmolested.

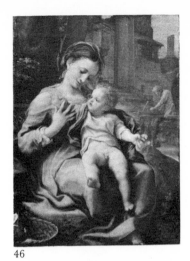

46

47

48

49 Giorgione (active 1506, died 1510) *Sunset Landscape with Saints, 'Il Tramonto'*

$28\frac{7}{8} \times 36$

These saints, S. George in the background, S. Roch in the foreground seem to have strayed mistakenly into what is the real subject of the painting, the evocative almost eerie evening landscape in which a single tree stands out delicately against the sky. The landscape cannot be identified with that of the Veneto where Giorgione was brought up; but is an imaginary one, imbued with a mood that is as mysterious as the colour is poetic. Giorgione's known activity is spread over a period of no more than four years, yet his work, in particular his creation of this type of landscape, was to have a lasting influence on later painters.

50 Titian (active before 1511-1576) *An Allegory of Prudence*

30×27

The inscription reads EX PRÆTERITO (from the past) PRÆSENS PRVDENTER AGIT (the man of the present acts prudently) NI FVTVR – ACTIONE DETVRPET (so as not to imperil the future); and the three heads represent Old Age (Past), Middle Age (Present) and Youth (future). The three-headed monster underneath (wolf, lion and dog) is also a symbol of Prudence; the past is devoured as by a wolf; present action is strong, as a lion; and the future is hope, like the welcoming face of a dog. The old face on the left is a self-portrait of the artist who was probably in his eighties when the picture was painted. The centre face may be that of his son, and the youth to the right a relative who lived in the house of the aged painter.

51 X-ray photograph of Titian (active before 1511-1576) *'Noli me Tangere'*

$42\frac{3}{4} \times 35\frac{3}{4}$

After the Resurrection Mary Magdalene visited the sepulchre and found it empty. When Christ appeared to her she imagined Him to be a gardener (in Titian's picture He holds a hoe); and only when He spoke her name did she recognise Him. When she moved as to touch Him, he exhorted her: 'Noli me tangere' ('Touch me not'). In this early painting by Titian X-rays reveal changes in the composition: Christ, who may have been wearing a gardener's hat, originally walked away from the Magdalen, and a tree, once centrally placed, has been painted out by the artist.

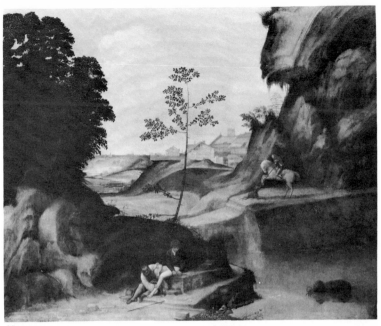

49

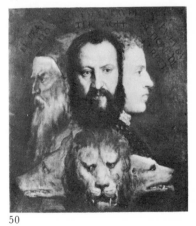

50

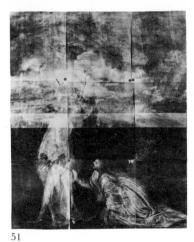

51

52 Titian (active before 1511-1576) *Bacchus and Ariadne*
69 × 75
Signed: TICIANVS F.

Ariadne, imagining herself to be loved by Theseus was deserted by him on the island of Naxos, where she subsequently spent her days wandering distraught along the sea shore. There she was discovered by the god Bacchus,* who, bringing in his train the drunken Silenus on an ass, satyrs and bacchantes, leapt from a carriage drawn by cheetahs, and instantly promised her marriage and a place among the stars as a constellation (visible above her). The picture, painted in 1522/23 is one of a series of four (by Titian and by Giovanni Bellini) which decorated the study of Duke Alfonso d'Este at Ferrara.

53 Titian (active before 1511-1576) *The Death of Actaeon*
70¼ × 78

The picture was probably painted in the mid-1560's as part of a series of paintings based on themes from Ovid which the artist executed for Philip II of Spain. This picture, which was among the last of the series, may however never have reached Spain. Actaeon, having discovered Diana and her nymphs bathing (Titian's version of this episode is now in the National Gallery of Scotland) was later transformed by her into a stag and devoured by his own hounds. His death is the subject of the present picture. The female figure who holds aloft an unstrung bow is not recognisably Diana; but is possibly a personification of the goddess's vengeance.

* In SEBASTIANO RICCI's treatment of the theme she is discovered by Bacchus as she lies, seductively exhausted in a woodland grove.

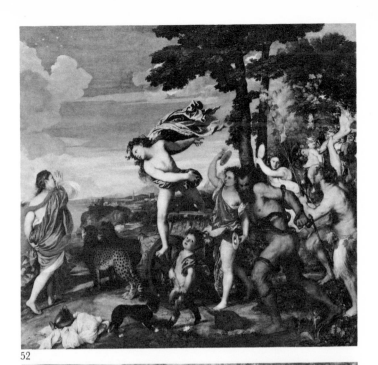

52

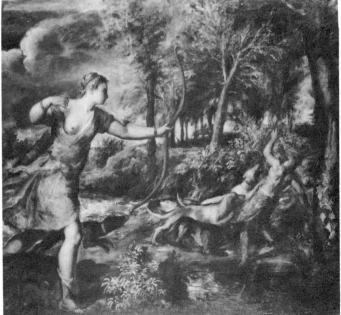

53

Room 9	**54** Tintoretto (1518-1594) *The Origin of the Milky Way*
	58¼ × 65
L. Floor	The vast CHRIST WASHING HIS DISCIPLES' FEET is the most 'typical' of the Gallery's four Tintoretto's, being of a religious subject in which the main incident is dramatically highlighted. Mythological scenes such as *The Origin of the Milky Way* are rarer. Here Jupiter holds the infant Hercules to the breast of Juno but her milk spills upwards to form the stars of the Milky Way. Like Bacchus in Titian's picture nearby, the nude figure of Juno, suddenly springing into action, occupies a pivotal position in the composition.

Room 9	**55** Veronese (*c.* 1528-1588) *The Family of Darius before Alexander*
	93 × 187

Veronese depicts the scene, which took place in the 3rd century B.C., as taking place in the sumptuous and splendid setting of 16th century Venice. The mother of the Persian ruler Darius (Alexander the Great's defeated enemy) mistaking Alexander's friend for Alexander (who was the smaller of the two) offers him the obeisance due to the victorious king. Alexander magnanimously forgave her her mistake by saying of Hephaestion that he too was an Alexander. The picture may include portraits of members of the Pisani family for whose country house at Este it may have been painted, probably in the 1570's.

Room 9	**56** Veronese (*c.* 1528-1588) *An Allegory*
	73½ × 74¼

The picture is one of a set of four which may originally have decorated a ceiling. The four scenes possibly represent *Virtue* and *Unfaithfulness*, male and female. The unfaithful male is punished by Cupid while Chastity (carrying an ermine) leads the man's wounded lover away. The unfaithful woman is represented nude and, having conquered the soldier to her right, attempts to win the courtier to her left, while Cupid plays music to her command. The faithful male resists the efforts of Cupid to draw him to the bed of the sleeping woman while the faithful female is crowned with myrtle, possibly by Venus.

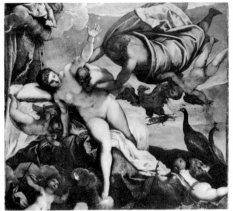

54

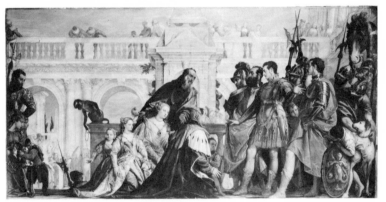

55

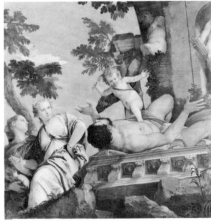

56

Room 29

57 Caravaggio (1571-1610) *The Supper at Emmaus*

55½ × 77¼

After the Resurrection two of the Disciples, having been joined on the road to Emmaus by a stranger whom they did not recognise as being Christ, later invited Him to sup with them. When He took bread, and blessed it (as at the Last Supper) they recognised Him, and this is the moment which Caravaggio depicts. The basket of fruit about to fall from the table, the gestures of Christ and the Disciples, and the close-up view of the scene, all emphasised by the dramatic lighting, serve to involve the spectator in the action in a manner which is characteristic of the painter.

Room 29

58 Domenichino (1581-1641) *S. George killing the Dragon*

20¾ × 24⅜

Notice how Domenichino frames with tall trees on either side the frieze-like scene of S. George killing the dragon in the foreground with the Princess fleeing to the left. Behind stretches a beautiful and extensive landscape. Domenichino, who worked in Rome, creates depth in the picture by the subtle change of tone from dark foreground to light horizon. Later in the 17th century and also in Rome, Claude (see figs. 92-95) would instil warmth into these damp classical landscapes as pioneered by Domenichino.

Room 29

59 X-ray photograph of Annibale Carracci (1560-1609) *'Domine, Quo Vadis?'*

30½ × 22

S. Peter, fleeing from Rome, encounters a vision of Christ on the Appian Way. In reply to Peter's question, Christ replies that he is going to Rome to be crucified a second time. S. Peter draws back at the dramatically advancing figure of Christ; indeed X-ray photographs reveal that S. Peter was originally painted in a more upright position.

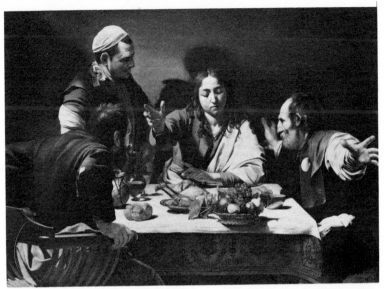

57

58

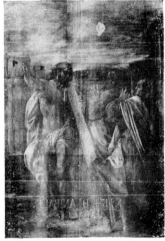

59

60 Adam Elsheimer (1578-1610) *The Baptism of Christ*

$11\frac{1}{16} \times 8\frac{1}{4}$

Elsheimer was a German painter who, having visited Venice, was living in Rome by 1600 where he died a decade later. His use of several light sources within his pictures may have been derived from Tintoretto and Caravaggio, and his tiny pictures, painted on copper were to influence such artistic giants of the 17th century as Rubens, Rembrandt and Claude. In this picture an angel descends ready to clothe Christ who is being baptised in the foreground. To the right a separate incident shows S. Peter removing the Tribute Money from the fish, while a small scene (left) shows Christ calling the fisherman S. Peter to be one of His disciples.

61 Guido Reni (1575-1642) *The Adoration of the Shepherds*

189 × 126

Reni's treatment of the theme of the *Adoration of the Shepherds* should be borne in mind when looking at other paintings of the Nativity in the Gallery. This, the largest picture in the collection, is an altarpiece painted subsequent to the Counter-Reformation, and so all details of the picture unite to demonstrate to the spectator as simply as possible the religious significance of the scene. The light from the Christ Child illuminates the faces of the humble shepherds as they gaze in wonder; while above rejoicing angels bear the message 'Glory to God in the highest'. Reni's 17th century classical style owes much to Raphael.

62 Guercino (1591-1666) *Angels weeping over the Dead Christ*

$14\frac{1}{2} \times 17\frac{1}{2}$

This small almost private devotional picture is an early work by Francesco Barbieri, called Guercino (meaning squint-eyed). Executed in the artist's characteristically beautiful and nocturnal colours, the picture has a quiet piety as the angels grieve beside the dead body of Christ. The theme, almost a *Pietà*, was one which appealed to the 17th century, demonstrating as it does Christ's suffering or sacrifice (in order to save sinners).

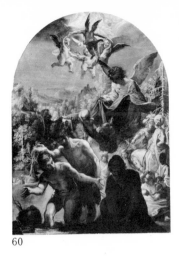

60

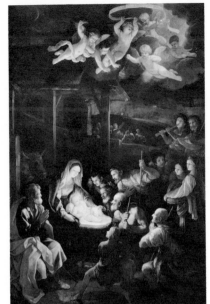

61

62

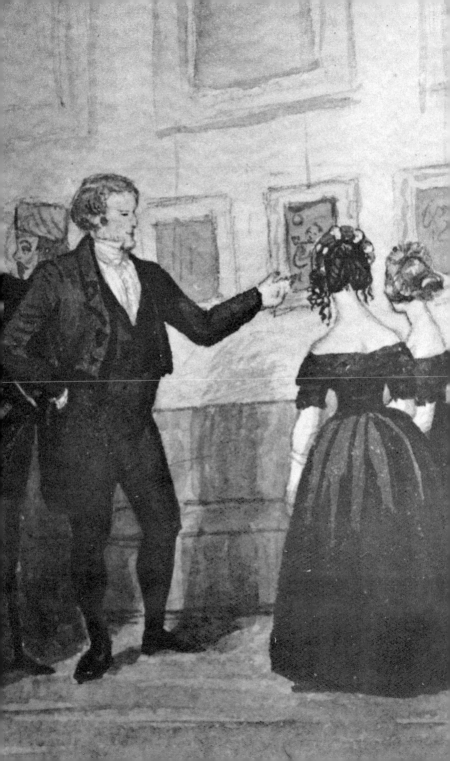

5 Rembrandt and the Dutch School

Miss Jemima Wedderburn, *Sir Robert Peel showing his pictures* (detail)

National Portrait Gallery

Sir Robert Peel (the Prime Minister) considered the type of early Italian pictures as purchased by Eastlake to be 'curiosities' and he himself assembled a collection which was predominantly Dutch. After his death the National Gallery purchased seventy-seven of his pictures (in 1871), fifty-five of which were Dutch. They included the celebrated *Avenue at Middelharnis* by Hobbema (fig. 78) and two paintings by de Hoogh.

Rembrandt and Cuyp have always been beloved by British collectors, and both artists have been represented at the National Gallery from the day it first opened, May 10th, 1824. Two other great Dutch painters, Hals and Vermeer, did not take their place in the Gallery until 1876 and 1892 respectively; but this is because both artists were virtually unknown until the late 19th century. Lesser Dutch painters were known to British collectors from about the middle of the 18th century, but it was only in the second half of the 19th that they were avidly collected. Their 'well-made' quality appealed to the Victorians who appreciated evidence of diligence in a picture. Three private collections form the nucleus of the National Gallery's holding of the Dutch School: the Wynn Ellis and Salting collections bequeathed in 1876 and 1910 respectively and Sir Robert Peel's collection purchased in 1871.

The National Gallery has many Rembrandts; but then the artist painted a great deal, chiefly portraits, but also biblical and mythological subjects and landscapes. By the time he was twenty-six he was working in Amsterdam and had become famous and was subsequently to be very successful. He had a rich and pretty wife (fig. 68) and, when she died, took a mistress (fig. 71) who looked after his financial affairs after he had been declared bankrupt in 1656. His mistress and son Titus both predeceased him by a few years, leaving his only daughter to tend him on his death bed at the age of sixty-three. It is customary to regard Rembrandt's life as having been relatively tragic. The power of many of his portraits (not least the self-portraits) lies in his compassionate treatment of the sitter. His compositions depend, not upon elaborate poses, but almost entirely upon juxtaposed areas of light and dark. His free brushwork, itself a glamorous technique, removes all glamour from the sitters; and his wondrous colouring suggests the age of well-polished mahogany. Combined, these elements produce portraits that are very moving, and it does not do to think that these time-worn saddened people may in fact have been very happy. Rembrandt's style imbues his sitters with a universal humanity, and this is possibly the key to the enduring appeal of his portraits.

Holland is a flat (fig. 75), northerly country, which during the 17th century was inhabited principally by

well-to-do middle-class Protestants who lived in small houses (fig. 65), collected pictures and loved parties. Religious pictures were naturally not popular, so churches remained unencumbered by altarpieces etc. Like several other countries, Holland had a coastline; but its beaches were cold, windy and very long. Unlike other countries however, much of Holland was situated below sea level, so that boats, of necessity, played an important role in the lives of the people (fig. 74). With so much water it followed that in winter when it snowed, there was a great deal of ice, and skating was very popular (fig. 81). Although the sun rarely shone at any time of the year, it did sometimes set (fig. 72); but days were short, so that light in any form remained something of a novelty. All the people loved music and flowers; while most women were obsessed by household cleanliness (figs. 65, 83). The men often dressed as soldiers, but as they were wealthy enough to employ mercenaries to protect their frontiers, they could afford to spend most of their time in taverns. The visitor who bears these few simple facts in mind will find the Dutch collection at the National Gallery a source of unending interest and delight. The fact that some painters worked in Haarlem, some in Delft, some in Utrecht etc. is a matter of relative un-importance, although some artists, for example Vermeer, Hals, Cuyp and Jacob van Ruisdael, did create real masterpieces out of subject matter that was fascinatingly mundane.

63 Gerrit Berckheyde (1638-1698) *The Market place and the Grote Kerk at Haarlem*

$20\frac{3}{8} \times 26\frac{3}{8}$

Signed: *Gerrit Berck Heyde/1674*

Berckheyde was a native of Haarlem although he also worked in Amsterdam and The Hague. Another picture by him in the National Gallery (Cat. no. 1451) shows the interior of the church depicted here, the GROTE KERK AT HAARLEM. Although several Dutch painters painted scenes with the sun rising or setting, Berckheyde and Jan van der Heyden (q.v.) seem to have been two of the rare masters who ever actually saw it shining.

64 Jan Steen (1625 or '26-1679) *Music Making on a terrace*

$17\frac{1}{4} \times 23\frac{7}{8}$

Signed: *JSteen* (*JS* in monogram)

Dutch girls were shy about courting and generally left the men to do all the talking, while they pretended to be engaged in some other activity. Here the scene has an unexpected, almost Italianate elegance, and the men wear fancy dress. Their costumes were possibly inspired by the Italian *Commedia dell' Arte*.

65 Samuel van Hoogstraten (1627-1678) *A Peepshow with views of the interior of a Dutch house*

Signed on a letter on the floor of the box: *A Monsieur/Mon(ˢ?) S: de Hoogstraten /a/ . . .d(.)-echt.*

Perspective boxes, which were possibly first developed in Italy in the 15th century, were not uncommon in 17th century Holland. Hoogstraten and Carel Fabritius were contemporary pupils in the studio of Rembrandt; and the VIEW OF DELFT by Fabritius may well also be part of a perspective box. The exaggerated perspective of that view would suggest that it was painted for a triangular shaped box.

63

64

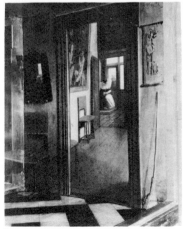

65

Room 19 **66** Rembrandt (1606-1669) *The Woman taken in Adultery*

$33 \times 25\frac{3}{4}$

Signed: *Rembrandt. f. 1644*

The Scribes and Pharisees bring an adulteress before Christ in the Temple and, reminding Him that Moses had commanded that such women should be stoned, ask Him for his judgement. He replied 'He that is without sin among you, let him first cast a stone at her', and they 'convicted by their own conscience' went out. Rembrandt, with a dramatic light, illuminates the scene inside the lofty temple.

Room 19 **67** Rembrandt (1606-1669) *Self portrait aged 34*

$40\frac{1}{8} \times 31\frac{1}{2}$

Signed: *Rembrandt. f. 1640*

Room 19

Room 9

This is one of about sixty surviving self-portraits of the artist and should be compared with the other SELF PORTRAIT AGED 63 in the Gallery. More interesting however is a comparison of the picture with a possible TITIAN SELF PORTRAIT painted about 1512. This Titian (or a copy of it) was between 1637 and 1641 in a collection in Amsterdam (where Rembrandt was living from about 1632), and there Rembrandt would have seen it.

Room 19 **68** Rembrandt (1606-1669) *Saskia van Ulenborch in Arcadian costume*

$48\frac{5}{8} \times 38\frac{3}{8}$

Room 25

Saskia was Rembrandt's wealthy wife whom he married in 1634, the year before this picture was painted. They had four children of which only one son Titus survived his mother, who died in 1642. Saskia was 23 when the portrait was painted, and Rembrandt has depicted her in Arcadian costume, a type of fancy dress popular in Holland in the 1630's. Saskia however, no more than any of the other Dutch women who dressed as shepherdesses at the time, has no intention of actually tending sheep, as a comparison of her costume with that of the real shepherdess/milkmaid in Cuyp's LANDSCAPE (fig. 72) makes clear. Her dress is painted in a range of pastel shades unique among the Rembrandts in the National Gallery.

66

67

68

69 Rembrandt (1606-1669) *Belshazzar's Feast*

$66 \times 82\frac{3}{8}$

Signed: *Rembrand./f 163(?)*

At a banquet for his princes, wives and concubines, Belshazzar, King of Babylon, uses the gold and silver vessels stolen from the temple in Jerusalem. The hand of God appears and in writing the words *Mene, Mene, tekel upharsin* on the wall prophesies the downfall of Belshazzar's kingdom. The Hebrew writing is to be read vertically from right to left. Compare the painting with another 17th century biblical scene of dramatic revelation in

the Gallery: Caravaggio's SUPPER AT EMMAUS (fig. 57). Caravaggio's use of light influenced Rembrandt; but the latter's stupendously thick impastoed paint is quite alien to the earlier master's style.

70 Rembrandt (1606-1669) *A Man in a Room*

$21\frac{11}{16} \times 18\frac{5}{16}$

Traces of a false signature: *Rem (.)randt.*

This is the earliest Rembrandt in the Gallery and was probably painted about 1628/29. (The artist's earliest known dated picture is of 1625.) After a sojourn of about six months in the Amsterdam studio of Pieter Lastman* during 1624/25 Rembrandt returned to his native Leyden where he worked until about 1632 when he moved to Amsterdam. This type of subject matter, an astrologer or philosopher at study attracted him during those Leyden years. It was also treated by other Dutch artists of the

period, see for example BOL (Cat. no. 679) and LEYDEN SCHOOL (Cat. no. 2589). Adrian van OSTADE (Cat. no. 846) satirised the genre in his painting of 1661.

71 Rembrandt (1606-1669) *A Woman bathing in a Stream*

$24\frac{5}{16} \times 18\frac{1}{2}$

Signed: *Rembrandt f 1655*

The picture may be a portrait of Hendrickje Stoffels with whom Rembrandt lived after the death of his first wife Saskia (fig.68) and who bore him a daughter in 1654.** In Rembrandt's little picture she would appear to have lost something in a dark and shallow pool. Her subsequent cautious search for it, skirts held aloft, instead of deterring her from midnight bathing in future, would seem in fact to be causing her a good deal of quiet amusement.

* See the Lastman in the Gallery, JUNO DISCOVERING JUPITER WITH IO.
** See the recently acquired portrait of HENDRICKJE.

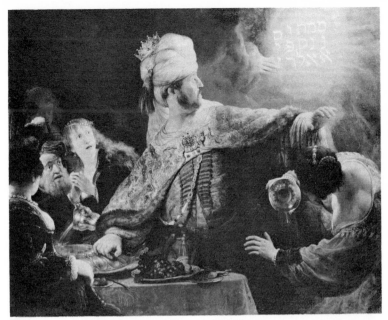

69

70

71

Room 25 **72** Aelbert Cuyp (1620-1691) *A Milkmaid and Cattle near Dordrecht*

$62 \times 77\frac{1}{2}$

Signed: *A. cüyp*

Although Cuyp never travelled to Italy his work was influenced by that of the Dutch painters who did, notably Jan Both who returned to Holland from Italy in 1641. Cuyp's views in Holland are imbued with a golden evening light reminiscent of the Roman campagna; and by often painting from a low viewpoint he exaggerates the contour of distant hills and buildings so as to create more of a 'composition' than was usual with other Dutch landscape painters. There are several views by Jan Both (*c.* 1618(?)-1652) in the National Gallery.

Room 26 **73** Frans Hals (*c.* 1580(?)-1666) *A Family group in a landscape*

c. $58\frac{1}{2} \times 98\frac{3}{4}$

Probably painted in the late 1640's; the landscape is not by Hals. Hals, who worked in Haarlem, had a lively, broad technique which appeals to us to-day. Painted predominantly in tones of black and grey, his sitters have an appealing directness, in contrast to the more contemplative portraits of his contemporary Rembrandt.

Room 25 **74** Jan van de Cappelle (*c.* 1623/25-1679) *A River scene with Vessels Becalmed*

$44 \times 60\frac{1}{2}$

Signed: *J. V. Cappelle*

Cappelle was noted chiefly as a painter of seascapes, of which there are nine in the National Gallery. The present picture is characteristic and shows a crowded estuary scene with the sails of the ships carefully reflected in the shallow water.

72

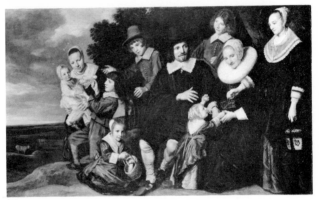

73

74

75 Philips Koninck (1619-1688) *An Extensive Landscape with a hawking party*

$52\frac{1}{4} \times 63\frac{1}{8}$

Koninck, who also painted portraits and genre pieces, was born in Amsterdam and worked there for the most part of his life. He may have been a pupil of Rembrandt. This picture was possibly painted some time in the early 1670's.

76 Rembrandt (1606-1669) *Margaretha Trip*

$51\frac{3}{8} \times 38\frac{3}{8}$

She, who was born Margaretha de Geer, was the wife of JACOB TRIP, a merchant from Dordrecht. They had been married in 1630 and had at least twelve children. Another, head and shoulders portrait of MRS. TRIP by Rembrandt is in the Gallery, and is dated 1661. The two larger portraits were probably painted in the same year. She was then aged 78, her husband was 86 and in the last months of his life when the portrait was painted. Her costume is of some forty years earlier.

77 Jacob van Ruisdael (1628 or 1629-1682) *A Landscape with a ruined castle and a church*

$43 \times 57\frac{1}{2}$

Signed: *JvRuisdael* (*JvR* in monogram)

Painted in the early morning and probably in late September or October (the corn though harvested is still in the fields). The day's first light breaks through the clouds and illuminates the field and windmill in the centre if the picture. It is only later that one spots the shepherds to the left and the swans in the moat. This is a view of breathtaking quality by the greatest of all Dutch landscape painters.

75

76

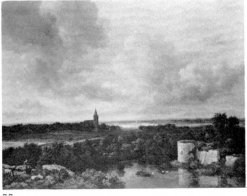

77

Room 27

78 Meyndert Hobbema (1638-1709) *The Avenue at Middelharnis*

$40\frac{3}{4} \times 55\frac{1}{2}$

Signed: *M:hobbema / f 1689*

This unpretentious masterpiece exudes a strange and potent fascination for most visitors to the National Gallery, where it has long been among the most popular of all pictures. The view is real; Middelharnis is on an island in the mouth of the Maas in South Holland, and the trees on the avenue were planted in 1664, twenty-five years before Hobbema painted them. Like Panini's view of the INTERIOR OF ST. PETER'S, some of the picture's spell is no doubt cast by the artist's blatant and almost magical creation of depth within the scene.

Room 35

Room 27

79 Rembrandt (1606-1669) *An Old Man in an Armchair*

$43\frac{5}{8} \times 34\frac{5}{8}$

Signed: *Rembrandt.f. / 1652*

The picture, which pays homage to Venetian 16th century portraits such as those by Tintoretto, has a private quality, and assumes the nature of a study as the artist experiments with technique. The man's left hand and sleeve are quite different in execution (and in scale) to his right. His bald head is the part most strongly illuminated, while his face is in shadow. Rembrandt could not conduct such experiments when painting a commissioned portrait.

Room 27

80 Rembrandt (1606-1669) *An Equestrian portrait*

116×95

Possible remains of a signature: *R . . brandt 1663(?)*

As a life-size equestrian portrait, Rembrandt's portrait of an unidentified officer of a civic guard is almost unique in the history of Dutch painting. The rider, elegant in his uniform, has a courtly air; so too has his horse who performs a *levade* and is resplendent in a 'dress' harness. The figures in the background to the left would appear to be occupants of a coach. The Gallery's only other equestrian portrait is the enormous CHARLES I by Van Dyck (fig. 87) of some thirty years earlier.

Room 21

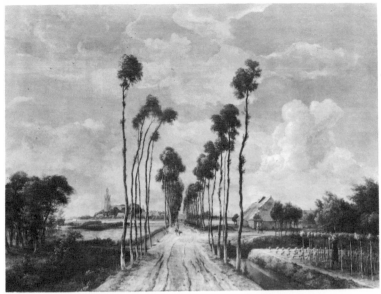

78

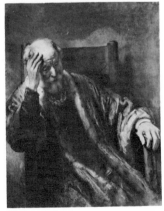

79

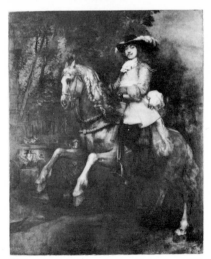

80

81 Hendrick Avercamp (1585-1634) *A Winter scene with skaters near a castle*

Diameter 16

Signed: *HA* in monogram

Though born in Amsterdam, Avercamp spent most of his life at Kampen. Since he was dumb he was referred to as 'de stomme van Campen'. The two pictures by him in the National Gallery, being typical of his work, lead one to suspect that the Dutch summer may have disagreed with him.

82 Vermeer (1632-1675) *A Young Woman standing at a Virginal*

$20\frac{3}{8} \times 17\frac{13}{16}$

Signed: *IV Meer* (the capitals are in monogram)

Both paintings by Vermeer in the Gallery are typical of the artist who worked in Delft. Both show a domestic interior in which a single figure, playing a musical instrument, hesitates for a moment, as though alerted by the spectator. The paintings on the walls in the background of each picture may allude to Vermeer's subject matter. In the one *Cupid*, holding aloft a blank playing card, may refer to the hazards of love; in the other the allusion is more problematic as the painting (by a contemporary artist Theodoor van Baburen) is of a *Procuress and her clients*. Vermeer, more than any of his contemporaries, conveyed the effects of light falling in a way that is entirely magical.

83 Pieter de Hoogh (1629-after 1684(?)) *The Courtyard of a House in Delft*

$28\frac{15}{16} \times 23\frac{5}{8}$

Signed: P.D.H. / AN⁰ 1658. (AN⁰ in monogram)

de Hoogh was a contemporary of Vermeer in Delft until he moved to Amsterdam early in the 1660's. As in the paintings of several Dutch artists opened doors in his pictures often lead to secondary scenes which are made enticing to the spectator by the clever use of light. The tablet seen above the arch in this picture still survives in Delft, translated it means: 'This is in S. Jerome's vale, if you wish to repair to patience and meekness. For we must first descend if we wish to be raised.'

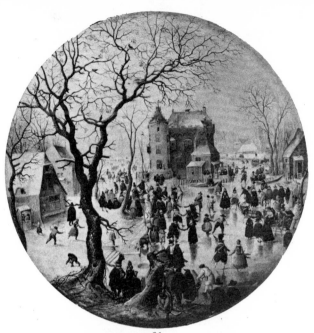

81

82

83

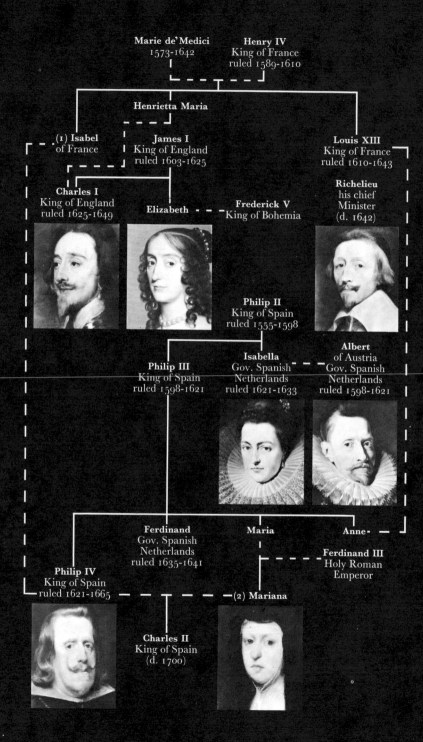

Marie de' Medici
1573-1642

Henry IV
King of France
ruled 1589-1610

Henrietta Maria

(1) Isabel
of France

James I
King of England
ruled 1603-1625

Louis XIII
King of France
ruled 1610-1643

Charles I
King of England
ruled 1625-1649

Elizabeth - - - Frederick V
King of Bohemia

Richelieu
his chief
Minister
(d. 1642)

Philip II
King of Spain
ruled 1555-1598

Philip III
King of Spain
ruled 1598-1621

Isabella
Gov. Spanish
Netherlands
ruled 1621-1633

Albert
of Austria
Gov. Spanish
Netherlands
ruled 1598-1621

Ferdinand
Gov. Spanish
Netherlands
ruled 1635-1641

Maria

Anne

Ferdinand III
Holy Roman
Emperor

Philip IV
King of Spain
ruled 1621-1665

(2) Mariana

Charles II
King of Spain
(d. 1700)

6 Flemish, French and Spanish Painters of the Seventeenth Century

In the first half of the 17th century Rubens was employed
as diplomat and painter at the Courts of Spain, France,
England and the Spanish Netherlands.
In the period Spain and the Spanish Netherlands were
Catholic and ruled by the Habsburgs; France under
Louis XIII was also Catholic; England under Charles I,
and the Northern Netherlands, were Protestant.
In the table opposite relations by marriage are indicated
by dotted lines, blood relations by continuous lines.
The portrait of *Elizabeth of Bohemia* by Honthorst is on
loan to the National Portrait Gallery.

The Flemish painter Van Dyck was Court Painter to the English King, Charles I; and to Van Dyck the British owe their image of that doomed Caroline Court. Reynolds called him the 'first of portrait painters', and English portrait artists of later generations often nostalgically depicted their sitters in what was loosely referred to as 'Van Dyck costume'. Rubens too (older than Van Dyck) worked in England: his ceiling of the Banqueting House, Whitehall, completed in 1635, is a rare and important example in this country of Baroque decorative painting. Both artists have been represented and revered at the National Gallery from its foundation, while Van Dyck's EQUESTRIAN PORTRAIT OF CHARLES I was purchased from the Duke of Marlborough in 1885.

Room 21

Room 32
The French painter Claude was known in England during his lifetime, and from the early years of the 18th century he was eagerly sought by British collectors. His influence, both on British painters and on British land-scape (through the work of 18th-century landscape gardeners), is almost inestimable. Poussin too, though less popular, has always been collected.

Room 32

Lady Eastlake (wife of the first Director of the National Gallery, and an art historian in her own right) wrote in 1854: 'Murillo and Velázquez are indubitably great masters, but with them the glories of the Spanish School pretty well begins and ends'. Both artists have been represented at the National Gallery since 1837 and 1846 respectively, and in 1895 the first El Greco was acquired.

Room 41

Outside of Italy, the 17th century saw in Europe the assassination (or as some thought the martyrdom) of the English King, the rise to power of France under Richelieu, and the decline of the Habsburgs in Spain. Catholics fought with Protestants, and vice versa; Habsburgs fought with non-Habsburgs and vice versa; and all international affairs were complicated by the fact that most rulers were related one to another. While much painting in the period served, with the rhetoric of the Baroque, the Catholic Church, the same rhetoric was employed by painters, Rubens, Velázquez and Van Dyck among them, to celebrate temporal patrons.

This 17th century European stage is set in the National Gallery with the help of portraits. Van Dyck's CHARLES I (fig. 87), Velázquez's PHILIP IV (fig. 100) and Philippe de Champaigne's RICHELIEU (fig. 91) play the leads.

Room 21
Room 41
Room 32

Lesser roles are taken (in lesser pictures) by the aunt and
uncle-by-marriage of Philip, ISABELLA and ALBERT of the
Spanish Netherlands (studio of Rubens)*, and the epilogue
is recited by mourning MARIANA OF AUSTRIA, widow of
Philip IV (Juan Bautista Mazo). The goddess *Minerva*
(having lost twice in a beauty contest (fig. 86)), agitates
the drama by physically rebuffing *War* and protecting
Peace (fig. 84), and later supports Charles I's unworthy
favourite, BUCKINGHAM: Rubens would have us believe
that she is escorting him to a temple of Virtue.

Amidst these lively and 'emotional' canvases of Rubens
and Van Dyck a more sober note is struck by the work of
two French artists who worked in Rome: Claude and
Poussin. Claude evolved a canon for classical landscape
compositions that was to influence painters in Europe for
almost two centuries; and the paintings of Poussin have a
classical coherence derived from scrupulous artistic study.

L. Floor A

L. Floor F
Room 20

Room 20
Room 22

Room 32

* At present on loan from the National Gallery.

95

84 Rubens (1577-1640) *Minerva protects Pax from Mars*
c. $80\frac{1}{8} \times 117\frac{5}{16}$

Rubens, as the ambassador of Philip IV (fig. 100) had success-fully negotiated a peace treaty between Spain and England in 1629. The following year he was knighted by Charles I (fig. 87) to whom he presented the present picture. The nude Goddess Pax nurtures infant Plutus – God of Wealth, as she is protected from Mars – God of War by helmeted Minerva. A satyr proffers fruit from a cornucopia signifying Plenty and Happiness; a putto in the sky brings symbols of Concord and Peace (the Caduceus and olive wreath); while Hymen bearing a torch crowns a young girl, suggesting that marriage flourishes in peace time. Hymen and two of the girls are probably portraits of the children of Sir Balthasar Gerbier with whom Rubens lodged in London.

85 Rubens (1577-1640) *A Roman Triumph*
$34\frac{1}{8} \times 64\frac{1}{2}$

This jewel-like canvas, crowded with incident and exquisite detail (see back cover) is derived from Mantegna's series *The Triumph of Julius Caesar*, now at Hampton Court, but in the collection of the Duke of Mantua at the time when Rubens was in the Duke's service between 1600 and 1608. The picture itself is a triumph of colour: study for example the variety in Rubens's treatment of the various flesh tones; and with no more than seventeen figures the artist suggests a tumultous procession. Friendly elephants wearing hats made of fruit-baskets bring up the rear.

86 Rubens (1577-1640) *The Judgement of Paris*
$57 \times 76\frac{1}{4}$

Paris accompanied by Mercury, awards the golden apple to the most beautiful of the goddesses, Venus; while Juno attended by her peacock, and Minerva, recognisable by her willingly discarded armour, remain as yet unmoved by the fury Alecto
above. The subject (see also Rubens's JUDGEMENT OF PARIS of some thirty years earlier) afforded the artist the opportunity to make three studies of the female nude. It was probably painted between 1632 and 1635.

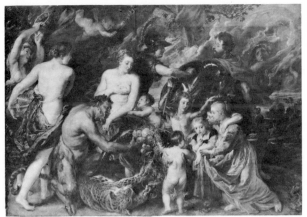

84

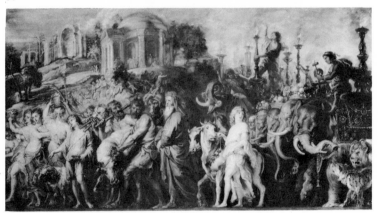

85

86

87 Van Dyck (1599-1641) *Charles I on Horseback*
c. 144½ × 115

Inscribed on the tablet hanging from the tree: *Carolvs. | Rex Magnae | Britaniae*

Charles I (1600-1649) became King of Great Britain and Ireland in 1625. Believing in the Divine Right of Kings, he ruled without Parliament from 1629 to 1640, a rule which led to civil war and his own subsequent execution. He made an important collection of paintings, patronised Rubens and appointed Van Dyck as his Court Painter in 1632. The popular idea that Van Dyck's portraits show a sense of foreboding and melancholy in the countenance of the King seems purely notional. How could the King be aware of his gloomy future? and a court painter who took the liberty of depicting his Sovereign as doomed might well find that he was not court painter for long.

88 Van Dyck (1599-1641) *The Abbot Scaglia adoring the Virgin and Child*

c. 42 × 47¼

Scaglia, on behalf of the House of Savoy, played an active part in promoting peace between England and Spain in 1629. The composition of this picture, which combines portraiture with a religious image, is of a type associated with the Italian High Renaissance (see for example SEBASTIANO DEL PIOMBO's Virgin and Child); but the design of the present picture derives from a lost picture by Titian, which Van Dyck sketched. The image of Scaglia however is entirely Baroque, expressing as it does the devotion and piety of the Abbot; and it should be looked at in the context of such images as that of S. JOHN THE EVANGELIST by Velázquez.

87

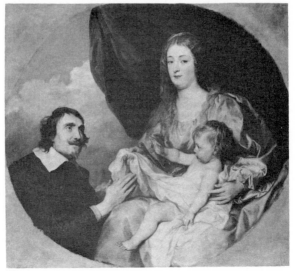

88

Room 22

89 Rubens (1577-1640) *A View of Het Steen*
$51\frac{3}{4} \times 90\frac{1}{2}$

The painting, painted on no less than seventeen panels (as indicated) is a view of Rubens's own country house which he bought in 1635, and to which he more or less retired in the last years of his life. The picture was painted about 1636. It is early morning and a laden cart bearing well-fattened merchandise leaves the house for the market. The town on the horizon may be Antwerp, the sportsman in the foreground possibly the artist himself.

Room 22

90 Rubens (1577-1640) *Susanna Lunden (née Fourment)* '*Le Chapeau de Paille*'
$31\frac{1}{16} \times 21\frac{1}{4}$

The sitter was probably an older sister of the artist's second wife, Helena whom he married in 1630. The portrait was possibly painted about 1622-1625, and although the sitter is clearly seen to be wearing a felt hat, the portrait has long been affectionately referred to as 'Le Chapeau de Paille' (The straw hat).* It is one of the most popular portraits in the gallery, and the sitter's coy injunction to the spectator to tarry a while, is almost always successful.

Room 32

91 Philippe de Champaigne (1602-1674) *Cardinal Richelieu*
$102\frac{1}{4} \times 70$
Inscribed: *P. de Champaigne*

Richelieu, who wears his cardinal's robes and the order of the Saint Esprit, was chief minister of France under the youthful Louis XIII. He was largely responsible for establishing France as a great power in Europe, and setting the stage for the subsequent glorious reign of Louis XIV. The painter was influenced by both Rubens and Van Dyck, and there are suggestions of both artists in this portrait; but the immense grandeur of the picture depends not only on the sumptuous painting of the draperies but also on the relative simplicity of the pose and the background architecture, which is set off by such details as the single tassel and the brilliantly silhouetted cardinal's biretta.

L. Floor D

* The French 18th century painter Madame Vigée Le Brun saw Rubens's picture in Antwerp, and subsequently painted her own SELF-PORTRAIT in imitation of it. In that picture, of which the National Gallery version is a copy, the painter does wear a 'chapeau de paille'.

89

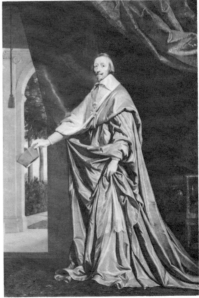

90

91

Room 32 **92** Claude (1600-1682) *A Seaport*

39 × 51

Signed: CLAVDIO G.I.V. ROMAE 1644(?)

The 'mass' of building on the left is counterbalanced by the smaller 'mass' of the ship on the right; a lighthouse sets the middle distance and the far horizon is strongly illuminated. This was the formula evolved by Claude for painting seascapes and landscapes alike.

Room 32 **93** Claude (1600-1682) *Hagar and the Angel*

20¾ × 17¼

Signed: CLAVDE/1646

Hagar, the biblical handmaiden of Sarah, pregnant by her mistress's husband Abraham, had, upon being scolded by Sarah, fled to 'a fountain of water in the wilderness'. There she is visited by an angel who tells her to return to work and stop being so silly. Claude interprets the 'wilderness' as described in Genesis in the most liberal fashion; and Hagar's retreat is in fact a lush and civilised landscape.

Room 32 **94** Claude (1600-1682) *The Marriage of Isaac and Rebekah ('The Mill')*

58¾ × 77½

Inscribed: MARI(*age*) DISAC/AVEC REBECA

Signed: CLAVDIO. G.L. I.N.V. ROMAE 1648/F. (?)

Although Claude has inscribed a title for the picture on the tree-stump in the centre, the real subject is the classical landscape, in the foreground of which figures are shown celebrating. The air is still warm after a hot day's sun; the huntsmen return home; cattle are driven down to drink; and the mill-wheel turns. Claude paints a poetic and pastoral world where time seems to be unknown.

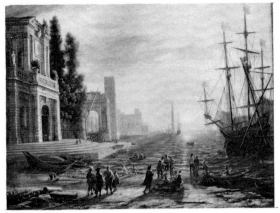

92

93

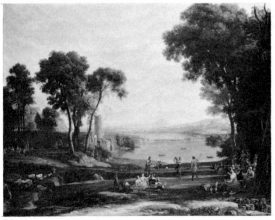

94

Room 32 | **95** Claude (1600-1682) *The Embarkation of the Queen of Sheba*

$58\frac{1}{2} \times 76\frac{1}{4}$

Inscribed: LA REINE DE SABA VA/TROV (*ver*) SALOMON

Signed: CLAVDE GL. I.V. FAICT. POVR. SON. ALTESSE. LE DVC DE / BVILLON A ROMAE. 1648

Room 32 | Painted in the same year as *Isaac and Rebekah*, the picture shows Claude employing the same compositional techniques for a seaport scene as he did with a landscape. The eye is led into the picture by the subtle gradations of tone from the dark foreground to the luminous horizon. The trees and the mill, which, like the wings of a theatre stage, 'framed' the scene in fig. 94 are here replaced by buildings; and from one of these the Queen of Sheba and her sumptuous retinue embark for the court of King Solomon.

Room 32 | **96** Poussin (1594?-1665) *Landscape with a man killed by a snake*

$47 \times 78\frac{1}{4}$

Poussin's classical landscapes, unlike those of Claude, almost assume a geometrical pattern. The forms of the buildings, and the landscape itself are defined by the fall of light and reduced to solid 'shapes', which are often reflected in water. The real subject of this picture (which was probably painted in 1648) is the different states of fear: the man running who has seen the man being killed by a snake is the most frightened; his terror is communicated to the woman, who cannot herself see the object of terror, so is less frightened. The fishermen in the boat are unaware of the drama and so are calm. As in several of his landscapes, Poussin derived this view from a real place. The town in the background is Fondi; the lake, the Lago di Fondi, and the hill-top village Monte San Biagio. The Plain of Fondi was infested with snakes in the 17th century (it still is), so the incident in the picture is also inspired by reality.

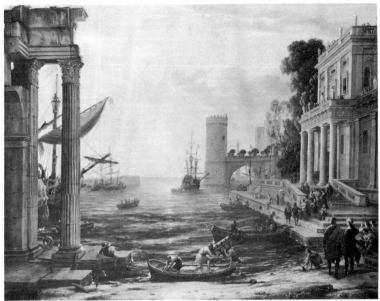

95

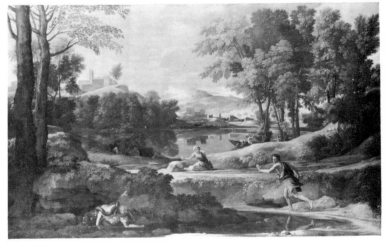

96

Room 32

97 Poussin (1594?-1665) *The Adoration of the Golden Calf*
$60\frac{3}{4} \times 84\frac{1}{4}$

Room 32

Moses (to the left), descending from Mount Sinai with the Tablets of the Law, smashes them upon discovering Aaron and the Israelites worshipping an idol: the Golden Calf. The religious theme was in fact an excuse for Poussin to paint a scene similar to a profane *Bacchanal*; and the poses of some of the figures should be compared to the earlier BACCHANALIAN REVEL BEFORE A TERM OF PAN. Poussin, in his early years in Rome, studied the bacchanals of Titian (see fig. 52); but his frieze-like deployment of the figures is much more classical than Titian's, as are most of the individual poses. Although all the figures are shown in movement as they gesture towards the idol, the picture has in fact a very static quality.

Room 41

98 Murillo (1617-1682) *Self-portrait*
$48\frac{1}{4} \times 42$

Rooms 9
19,29,45

Other artists' self-portraits in the gallery include those of TITIAN (?) REMBRANDT, SALVATOR ROSA and CÉZANNE. Murillo's, which was probably painted when the artist was in his fifties, was done, according to the inscription, 'to fulfill the wishes and prayers of his children' (of which he had nine). Murillo worked most of his life in Seville. His religious pictures were much copied and reproduced until well into the 19th century; however in reproduction much of their natural charm and beauty is lost and they appear instead depressingly sentimental and cloyingly pious, which they are not.

Room 41

99 Murillo (1617-1682) *The Two Trinities*
$115\frac{1}{4} \times c. 81\frac{1}{2}$

Room 41

This is a late picture by the artist and shows the Christ Child (standing), the Virgin (sitting) and S. Joseph (kneeling) as the Earthly Trinity, with God the Father, the Holy Ghost and the Christ Child as the Heavenly Trinity. Murillo's transformation in style from his early work (paintings such as the ADORATION OF THE SHEPHERDS), was remarkable; and influenced by the paintings of Rubens and Van Dyck (also Barrocci) which he would have seen in the Royal Collection on visits to Madrid. His people have a simple elegance that was new in Spanish painting, but much imitated.

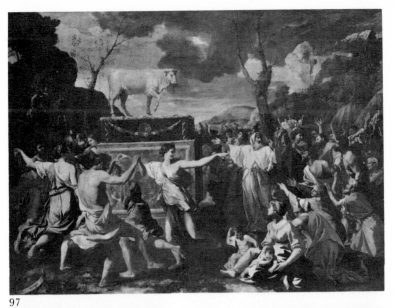

97

98

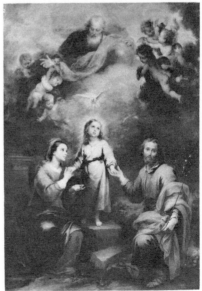

99

Room 41 **100** Velázquez (1599-1660) *Philip IV of Spain in brown and silver*

c. 76⅞ × 43¼

Signed on the paper in his hand: *Señor./Diego Velasqũz./Pintor de V. Mg.*

Philip IV (1605-1665), the Habsburg King of Spain, came to the throne in 1621. His reign saw the decline of Spanish power in Europe and he was succeeded by Carlos II, his epileptic son by his niece and second wife Mariana of Austria.* Velázquez was Philip's court painter from 1623 until his death, and this portrait was probably painted some time in the early 1630's when the king was in his late twenties. The picture is therefore
Room 41 about contemporary with the view of the king BOAR HUNTING,
Room 41 also in the gallery; the BUST PORTRAIT is much later and was probably painted about 1656.

Room 41 **101** Velázquez (1599-1660) *The Toilet of Venus* (*'The Rokeby Venus'*)

c. 48¼ × 69¾

The composition of the picture (called 'The Rokeby Venus' after Rokeby Park in Yorkshire where it hung for almost 100 years) is related to two 16th century Venetian traditions: Venus reclining on a bed, and Venus Seated, seen from the back and contemplating her face in a mirror, which may be held by Cupid. Velázquez visited Venice in 1629 and again in 1649/51; the picture may have been painted in the late 1640's, and possibly in Italy. *Venus* though she may be called, the real subject of the picture is a seductive female nude, and long though we may gaze at her she will never respond, and will never reveal more than the shapely back that she has displayed to generations. The mirror is a cheat and the image it shows unreal, held at such an angle it could not reflect the head of Venus, and even if it did it would mirror more than just her face.

L. Floor F *See her portrait, which includes in the background the child King Charles II, by Velázquez's pupil Mazo.

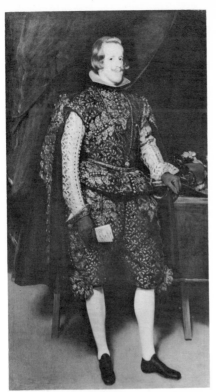

100

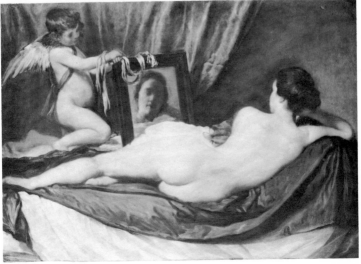

101

102 Velázquez (1599-1660) *Kitchen scene with Christ in the House of Mary and Martha*

$23\frac{5}{8} \times 40\frac{3}{4}$

Painted when the artist was working in Seville, and before he left for Madrid and the court of Philip IV (fig. 100) in 1623, the picture is one of several similar scenes, called *bodegones*, which he painted. The composition, derived from 16th century northern European prototypes, is based on a prominent foreground scene which relates in theme to another scene viewed through an opening in the background. Here the background scene is *Christ in the House of Mary and Martha*, where Mary Magdalen listens attentively at the feet of Christ, while Martha complains of being overworked in the kitchen. In the foreground the old woman points to the moral by directing the attention of the spectator to the unhappy cook pounding garlic.

103 El Greco (1541-1614) *Christ driving the Traders from the Temple*

$41\frac{7}{8} \times 51\frac{1}{8}$

Christ taking a 'scourge of cords' drives the traders from the Temple. The subject (which El Greco painted several times) was a popular one in the period of the Counter-Reformation, when it seemed to symbolise the Church purged of heresy. There are several versions in the National Gallery including

L. Floor C

L. Floor A

L. Floor G

one by Jacopo BASSANO; but the most interesting comparisons with El Greco's picture are the versions 'after' MICHELANGELO and by CAVALLINO. The latter's picture was based on the Michelangelo, El Greco's inspired by it. El Greco, who came from Crete, was settled in Toledo by 1577. He was much influenced by Michelangelo whose work he had seen during his years in Italy.

102

103

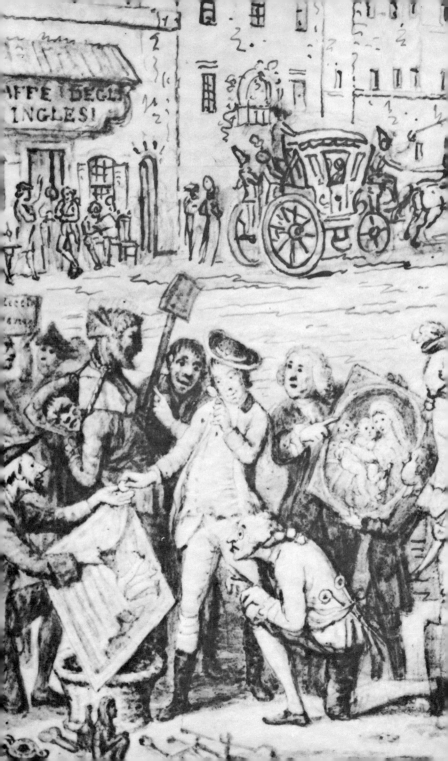

7 The Eighteenth Century

David Allan (1744-1796) *A Young English traveller in Rome in 1775* (detail)

By gracious permission of Her Majesty the Queen

The 18th century was the age of the Grand Tour when many of the paintings which have subsequently found their way to the National Gallery were bought by English travellers on the Continent. The taste of this young connoisseur would seem to lean towards contemporary painting, as he so patently ignores the dealer who offers him a copy of Raphael's *Madonna della Sedia* (here reversed as the drawing was made for engraving).

Two of England's great 18th century painters, Reynolds and Hogarth, have been represented at the National Gallery from its foundation; and in 1827, Gainsborough's WATERING PLACE was presented to the Gallery by a Trustee, Lord Farnborough. During his lifetime Canaletto was much patronised by English tourists in Venice, and indeed was persuaded to come to this country on three occasions between 1746 and 1756. It is fitting therefore that a masterpiece by him, THE STONEMASON'S YARD is one of the pictures, offered to the Nation by Sir George Beaumont in 1823, which contributed to the foundation of the National Gallery. It is now one of ten Canalettos in the Collection. It was the Gallery's third Director, Sir Frederick Burton, who laid the foundations of the 18th century Italian Collection: between 1881 and 1891 he purchased pictures by Giovanni Battista Tiepolo (two), Giovanni Domenico Tiepolo (one), Pietro Longhi (three) and Giuseppe Zais (two) as well as the much-loved portrait of Andrea Tron by Nazario Nazari. 18th century French painters have fared less well at the National Gallery, and it is to the Wallace collection in Manchester Square that the visitor to London should resort to savour fully the delights of the 18th century French school.

Room 34

Room 35

L. Floor F
Room 33

The 18th century was England's classical age, when an increasing and increasingly more prosperous aristocracy saw themselves as the heirs of ancient Greece and Rome. The houses which they built were in a classical style; their landscapes were classical, either loosely Arcadian or deliberately Roman (like the paintings of Claude); and in the portraits of themselves which they commissioned from painters and sculptors (and they commissioned little else) they were most often portrayed in classical poses and costumes. England's prosperity in the 18th century owed much to an increase in her agricultural output, and increased wealth led in turn to increased leisure. Colonisation abroad laid the foundations of the Empire, while at sea Britannia did indeed 'rule the waves'. Pictures in the National Gallery reflect all these aspects of 18th-century English life. Agriculture in Gainsborough's MR AND MRS ANDREWS, (fig. 110) leisure in Stubbs (fig. 112) classical architecture in Hogarth (fig. 109), classical costumes in Reynolds, power at sea in LORD HEATHFIELD, and colonisation (albeit unsuccessful)

Room 34
Room 34

Room 34

in BANASTRE TARLETON (fig. 114), a British hero of the American War of Independence.

An Italian picture by the Roman painter Pompeo Batoni shows TIME ORDERING OLD AGE TO DESTROY BEAUTY. The greatest Italian painters of the 18th century were Venetian, but their city even then, like Beauty in Batoni's picture, was crumbling with Age at the command of Time. In spite of this a certain optimism prevailed: Venus in Tiepolo's magnificent ALLEGORY (fig. 116) probably consigns the heir of some Venetian family to Time, thus suggesting the security of future generations of that particular family. Visitors to 18th-century Venice saw only the beautiful façade of the city as painted by Canaletto and Guardi, while the Venetian aristocracy themselves, as in the pictures of Longhi, avoided realities behind the costumes and masks of the carnival.

The French painter Watteau created a type of picture, the *fête-galante* (later taken up by Lancret and Pater) where lovers met and openly flirted in an outside and daytime world. This was in contrast to the Venetians whose intrigues, like themselves, they disguised (Longhi), or to the English who only recognised such things as taking place when they were sordid (Hogarth). In France, a warning note would seem to be sounded by Chardin. He emphasised the importance of education on the one hand (fig. 104) and seemed to suggest that the future, like a HOUSE OF CARDS might easily collapse. But the French were happy and the almost smiling faces in their portraits suggest a general kindliness and good humour.

In Spain, Goya was influenced in some of his early paintings by Tiepolo, but he lived long enough to paint the British soldier, Wellington, when the latter defeated Napoleon's brother in 1813.

Room 34
Room 38
Room 38
Room 35
Room 35
Room 33
Room 42
Room 42

Room 33 **104** Chardin (1699-1779) *The Young Schoolmistress*
24¼ × 26¼
Signed: *chardin*

Longhi in Venice, and Hogarth in England painted this type of every-day subject matter, which in itself is not far removed from the genre pictures of the Dutch 17th century. Hogarth however satirised and Longhi created little *tableaux vivants*, whereas Chardin, on the surface seems to have just recorded. But to the French 18th century spectator these exquisitely painted simple scenes probably suggested the importance of education and discipline. This picture may have been exhibited at the Salon in 1740.

Room 33 **105** Boucher (1703-1770) *Pan and Syrinx*
12¾ × 16½
Signed: *f. Boucher/1759*

Boucher's fleshy French girls have none of the inaccessibility of Tiepolo's contemporary but Italian nude *Venus* (fig. 116). These well-dimpled bellies and bottoms are painted for our delectation, and the fact that one of the girls is being chased by lusty Pan adds further to the naughtiness of the poses. The subject is taken from Ovid's *Metamorphoses*: she who reclines with her back to us leans on a jar and supposedly personifies the River Ladon. Syrinx plunging into the river, eludes the grasp of Pan and will shortly be metamorphosed into a reed. Thereafter Pan will use her for making his musical pipes.*

Room 33 **106** Lancret (1690-1743) *A Lady and a Gentleman with two girls in a garden*
35 × 38½

Such wild but yet civilised garden-groves appear also in the French 18th century paintings of Pater and Watteau in the Gallery; but in them and in the other paintings by Lancret they are the settings for adult games of love and intrigue. Here is the other side of French life: family life when doting parents amuse themselves with their children. The picture was exhibited at the Paris Salon of 1742, the last in Lancret's lifetime.

L. Floor * The alarm of Syrinx at being pursued by Pan is more convincingly conveyed in a Flemish 17th century version of the theme in the Gallery by Hendrick van Balen I.

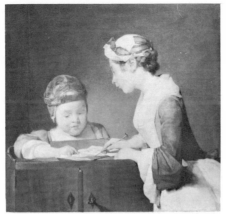

104

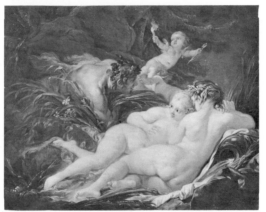

105

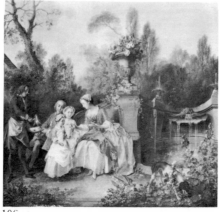

106

Room 33

107 Jean-Joseph Taillasson (1745-1809) *Virgil reading the Aeneid to Augustus and Octavia*

$57\frac{7}{8} \times 65\frac{3}{4}$

Signed: TAILLASSON 1787

The Emperor and his sister Octavia, seated upon a pair of very uncomfortable-looking chairs, are listening to the poet Virgil as he reads his poem *The Aeneid* from manuscript scrolls. Octavia has fainted, not as one might expect through exhaustion, but rather because the passage the poet has just read referred to her dead son Marcellus. Such affecting scenes appealed to neo-classical taste: the Emperor, though affected by the poem, remains stoically self-controlled, while Octavia is femininely overcome by grief.

Room 33

108 Jean-Marc Nattier (1685-1766) *Manon Balletti*

$21\frac{1}{4} \times 18$

Signed: *Nattier. p.x./1757*

Room 34

Unfortunately there is no mid-18th century English beauty in the Gallery to compare with Mademoiselle Balletti, while Gainsborough's MRS. SIDDONS of 1785 has a haughty and for-bidding Englishness in comparison to the open charms of the Balletti. She was an Italian actress working in Paris, and had the good fortune never to marry Casanova, even though she was engaged to him for about three years from the time this picture was painted. She later married the architect J.-F. Blondel.

Room 34

109 Hogarth (1697-1764) *The Marriage Contract*

$27\frac{1}{2} \times 35\frac{3}{4}$

Hogarth, in satirising high life, depicts in a series of six paintings the course of a marriage based on money and vanity. In the first picture a noble but penniless Earl Squander arranges a marriage for his son with the daughter of a rich but plebeian alderman. After the marriage the couple keep late hours and are seen breakfasting late in a disordered room. The consequence of the young husband's debauchery is venereal disease and he visits the doctor. The Countess, as she has now become, gives a levée, and develops a liaison with her lawyer. When they are discovered by the Earl, the lawyer kills him and escapes through a window, only to be subsequently hanged. When the Countess reads the news of his execution on a broad-sheet she commits suicide.

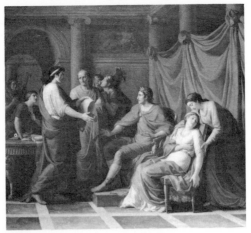

107

108

109

Room 34 **110** Gainsborough (1727-1788) *Mr and Mrs Andrews*
$27\frac{1}{2} \times 47$

Painted about 1752, when the artist as a young man returned to his native Suffolk after an apprenticeship in London, this little masterpiece is among the best-known and loved of all British paintings. The view of the cornfield, the distant fields and the cloudy sky is for most people the epitome of Englishness; and Mr Andrews is an English farmer who is proud of his well-harvested corn, neatly kept fences and well cared for sheep. The portrait is unfinished and Gainsborough may have intended Mrs Andrews to hold a book on her lap.

Room 34 **111** Gainsborough (1727-1788) *The Watering Place*
58×71

In an age when British patrons commissioned only portraits and collected only Old Masters, Gainsborough loved more than anything to paint landscapes. This picture, which was probably exhibited at the Royal Academy in 1777, possibly remained in the painter's studio and was sold by auction after his death. Gainsborough, who never travelled abroad, was influenced in his later years by the paintings of Van Dyck and Rubens which he saw in British collections; and this landscape owes much to
Room 22 a treatment of the same subject by Rubens, also in the National Gallery.

110

111

112 Stubbs (1724-1806) *The Melbourne and Milbanke families*

40 × 59

This delightful and recently acquired picture, depicting the members of an English aristocratic family with their animals in a landscape, was painted about 1770. The portraits are, from left to right, Viscountess Melbourne (née Milbanke), her father Sir Ralph Milbanke Bt., John Milbanke her brother and her husband the 1st Viscount Melbourne. Sir Ralph Milbanke was the grandfather of Anne Isabella Milbanke who married the poet Lord Byron. Hogarth satirised the English aristocracy, Reynolds invariably made them useful, Gainsborough gave them sensibility, but Stubbs more than any other painter in the National Gallery, in this picture, captured the spirit of their leisured and assured existence.

113 Reynolds (1723-1792) *Anne, Countess of Albemarle*

49¾ × 39¾

Reynolds, in attempting to elevate the British School of painting to a level equal with the Continental Schools ingeniously depicted many 18th century English sitters in poses derived from classical art. LADY COCKBURN AND HER CHILDREN therefore resemble an Italian Renaissance *Caritas* or *Holy Family*; and the artist 'generalises' the costume so that it too is 'classical'. Lady Albemarle's portrait by contrast is more informal, and for that more charming, showing as it does an English lady being an English lady, and not the Virgin Mary.

114 Reynolds (1723-1792) *General Sir Banastre Tarleton*

93 × 57¼

Banastre Tarleton who distinguished himself on the British side during the American War of Independence returned to England, a popular hero, in 1782. He was painted by Reynolds in that year. Portraits by Reynolds lack the sensitivity of technique which is the charm of those by his contemporary Gainsborough; but they excel by the brilliance of their compositions which owe much to the painter's diligent study of Italian Old Masters. Tarleton's pose is strikingly original, and the impetuousness of the young hero (who was 28) is suggested against the background of the smoking battlefield.

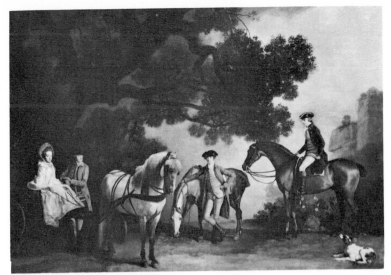

112

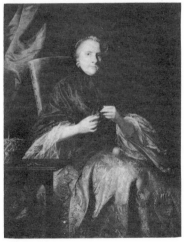

113

114

115 G. B. Tiepolo (1696-1770) *The Banquet of Cleopatra*
$17\frac{3}{8} \times 25\frac{13}{16}$

Cleopatra, in attempting to outdo the banquets of Mark Antony, gives a magnificent feast, at which to the astonishment of Mark Antony she dissolves one of her pearls in a goblet of vinegar. This is a sketch of a subject which Tiepolo painted several times. Characteristically he depicts the scene as taking place in 16th-century Venice, the splendour of which might be associated in the eyes of his contemporaries with the magnificence of Cleopatra's court.

116 G. B. Tiepolo (1696-1770) *An Allegory with Venus and Time*

115×75

The picture, which was painted as a ceiling decoration, was once in the Ca' Contarini in Venice, and was 'discovered' in 1969 on the ceiling of a house in London. It was probably originally commissioned from Tiepolo to celebrate the birth of an heir, and so Venus, depicted with her chariot and doves hovering above, consigns a baby boy to the care of winged Time. He, having dropped his scythe probably represents *Eternity* rather than *Mortality*, and the birth is celebrated by the Three Graces who prepare to shower the baby with petals.

117 Pietro Longhi (1702(?)-1785) *Exhibition of a Rhinoceros at Venice*

$23\frac{3}{4} \times 18\frac{1}{2}$

The Rhinoceros, which was probably the first seen in Europe for over two hundred years was brought to Venice for the carnival of 1751: it possibly found these strange masked Venetians every bit as curious as they found him. Unlike his English contemporary Hogarth, Longhi never satirised the social scene; but instead created *tableaux vivants* of a naïve simplicity based on the daily life of patrician Venetians. Their social round included taking coffee, visiting fortune-tellers and conducting intrigues.

115

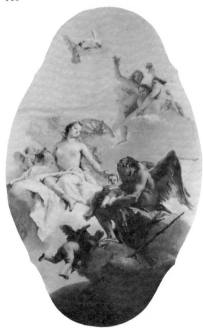

117

116

Room 35 **118** Canaletto (1697-1768) *Venice: Campo S. Vidal and S. Maria della Carità, ('The Stonemason's yard')*
48¾ × 64⅛

While most views of Venice by Canaletto and Guardi show the canals as lined by Palaces, the Piazza San Marco and the various splendid churches, this early Canaletto shows a 'back-stage' scene. In contrast to the idle life of the aristocracy as depicted by Longhi, here we see the working people of Venice, which the artist has depicted with an observation that is fascinating. The painting provides a rare glimpse of life in a city which throughout the 18th century preferred to show its façade: a façade which featured regattas of the Grand Canal and ceremonies such as the Wedding of the Sea.

Room 35 **119** Canaletto (1697-1768) *Venice: The Basin of S. Marco on Ascension Day*

48 × 72

The view, which is similar to that in a painting by Guardi in the Gallery, is towards the Doge's Palace, with the Campanile of S. Marco rising behind it. But Canaletto's view is taken on Ascension Day and shows the Doge's procession leaving the palace (preceded by blue standards) and making its way to his magnificent barge, the Bucintoro, on which he would be rowed to the mouth of the Lido for the traditional Ascension day ceremony of Venice wedding the sea. As usual Canaletto's view is painted precisely so that such details as the Doge's coat-of-arms on the Bucintoro are recognisable as those of the Doge Alvise Pisani who reigned from 1735 to 1741.

Room 42 **120** Goya (1746-1828) *The Duke of Wellington (1769-1852)*
25¼ × 20½

He is the first Duke of Wellington who defeated Joseph Bonaparte at the Battle of Vittoria in 1813. The portrait was painted in August 1812 when Wellington entered Madrid after winning the Battle of Salamanca; but two years later, in May 1814, he returned the portrait to Goya to have included his most recently awarded decorations. The alterations which Goya made to the costume and decorations are visible. Wellington now wears the Order of the Golden Fleece and the Military Gold Cross with three clasps (one for each of his battles). The three stars are (top) Order of Bath, (left) Order of the Tower and Sword (Portugal) and (right) Order of San Fernando (Spain).

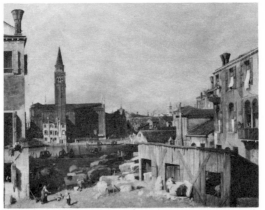

118

119

120

8 From 1824 to the present day

Sir William Orpen (1878-1931)
A Homage to Manet

64 × 51¼

City Art Gallery, Manchester

This picture shows Manet's portrait of Eva
Gonzalès which was bequeathed to the National
Gallery by Sir Hugh Lane in 1917. Lane's
bequest to the National Gallery included
paintings by Corot, Courbet, Boudin, and the
Gallery's first pictures by Manet, Monet,
Renoir, Pissarro and Degas. In the present
picture he is seated on the right and others
included are George Moore and the artists
Sickert, Tonks, Wilson Steer and MacColl.

Lord Liverpool, Prime Minister at the time of the foundation of the National Gallery, envisaged the national collection as consisting of works by modern artists and old masters. But by the end of the 19th century the Gallery had emerged clearly as an Old Master gallery and indeed by 1900 it had purchased no painting by a foreign artist of the 19th century. Constable was no sooner dead in 1837 when a group of well-wishers

Room 34 presented his CORNFIELD to the Gallery in his memory, while at a later date, Turner bequeathed a great number of his own paintings to the nation. The most important bequest to the Gallery of 19th-century foreign paintings was that of Sir Hugh Lane in 1917; while recent acquisi-

Room 45 tions have included Seurat's BAIGNADE (fig. 134) and
Room 44 Rousseau's TROPICAL STORM WITH A TIGER (fig. 130).

Constable hated the idea of a National Gallery and thought its establishment would mean 'an end of the art in poor old England. The reason is plain; the manufacturers of pictures are then made the criterion of perfection, instead of nature.' Turner's approval of the National Gallery on the other hand was nearly embarrassing: on his death he bequeathed almost three hundred oil paintings to the nation. Some of these still hang at Trafalgar Square, but the majority are in the Tate Gallery.

Room 34 Constable's response to nature, and Turner's use of colour and atmospheric effects, opened the way for later developments in 19th-century painting, particularly in France. The French Romantic painters, Géricault and

Room 43 Delacroix, were influenced by both English painters; and
Room 43 later artists such as Corot and Courbet, whose own work led on to the Impressionists, were also inspired by them. In seeking reality, Constable saw Nature in her true colours, and in that he was an innovator. The Impressionists, pursuing the same ideal, saw that those colours

Room 45 changed according to light. Cézanne moved away from atmospheric effects towards the underlying forms of nature, and his analyses of those forms opened the way for modern art.

121 Constable (1776-1837) *Weymouth Bay*

21 × 29½

Within the year 1815/16 both Constable's parents died and the painter married (in the Church of S. Martin-in-the-Fields) Maria Bicknell, overcoming, after a courtship of seven years, her family's opposition. For their honeymoon the couple stayed with Constable's friend and patron, Canon Fisher, at Osmington Vicarage near Weymouth, Dorset. It was the month of October and it was probably at that time that this unfinished picture was painted. Constable's direct response to nature is suggested by the wind-buffeted clouds, the cold sea and the light moving across the field in the middle distance.

122 Photograph of Willy Lot's house taken in 1927, the
scene of Constable's painting *The Haywain*

The picture is signed: *John Constable pinxᵗ. London 1821*

In the painting it is noon and presumably late summer: hay is being loaded on a cart in the background and another, *The Haywain* stands in the pond so that its wooden wheels will expand and tighten in their iron rims. The view is real; the house belonged to Willy Lot the painter's neighbour who lived there for more than eighty years, and was for Constable a symbol of rustic peace and continuity. Exhibited at the Royal Academy of 1821 and the Paris Salon of 1824, the picture made a tremendous impact on the public by virtue of the very 'naturalness' of the scene. This is now more difficult to appreciate as we are familiar with the work of later artists whose interpretation of nature was similar. Stendhal thought 'the delicious landscape the very mirror of nature' and the painters Delacroix and Gericault were also impressed.

123 Turner (1775-1851) *The 'Fighting Téméraire' tugged to her last berth to be broken up, 1838*

35¾ × 48

The painting was exhibited at the Royal Academy in 1838 by which time Turner's increasingly more freely painted pictures were already going out of fashion, and his work was being superseded by that of a younger generation of artists. *The Fighting Téméraire*, an old ship (which had fought in the Battle of Trafalgar), towed to its last berth by a modern steam tug, is about age: age contrasted with youth, or the old age contrasted with the new Industrial Age. The ghostly form of the *Téméraire*, is contrasted with the much smaller though more powerful black tug, and the poignancy of its last voyage is emphasised by the brilliantly setting sun.

121

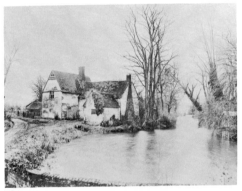

122

123

Room 34 **124** Turner (1775-1851) *Calais Pier; with French poissards preparing for sea: an English packet arriving*
67¾ × 94½

Turner, who travelled abroad for the first time in 1802, recorded his tempestuous landing at Calais in several sketches now in the British Museum, while he painted this picture as a subsequent impression of his experiences. Until about 1796/97 the artist had painted only in watercolour, and his earliest oils, of which the present picture is one, reflected a variety of influences: Dutch 17th century marine painting and the classical landscapes of Richard Wilson, Poussin and Claude. Even at this early stage of his career however, Turner manifested the interest in atmospheric effects that was to distinguish his entire *oeuvre*. When exhibited at the Royal Academy in 1803, the sea suggested to one critic 'the veins on a marble slab' and to another 'the appearance of butter'.

Room 43 **125** Ingres (1780-1867) *Madame Moitessier seated*
47¼ × 36¼

Signed: *J. Ingres 1856* / AET LXXVI

The portrait, which at one stage included the sitter's daughter (a detail which the artist later painted out) was begun in 1844/45 but not delivered until 1857. Ingres was a pupil of Jacques-Louis David in Paris and later worked in Italy for eighteen years. He was a superb draughtsman, and his classical style with its emphasis of contour and line was directly opposed to that of his contemporary, the colourist Delacroix. Ingres was influenced by Raphael and the Antique, and Madame Moitessier's pose is derived from an Antique mural from Herculaneum. Nevertheless Ingres captures splendidly the opulence of the Second Empire with his precise definition of the details of the costume and furnishings. The picture is exhibited in its original frame.

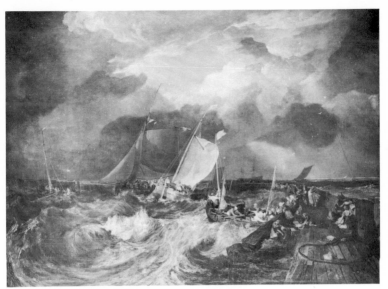

124

125

126 Delacroix (1798-1863) *Ovid among the Scythians*

$34\frac{1}{2} \times 51\frac{1}{4}$

Signed: *Eug. Delacroix/1859*

The Roman poet Ovid was banished from Rome to Constanza on the Black Sea in A.D. 8 and is thought to have died there about ten years later. The natives of the district were believed to have fed on mare's milk, an aspect of their existence which Delacroix indicates in the foreground of the present picture. Influenced by Rubens, Veronese and Constable, Delacroix was the leading painter of the Romantic movement in France, choosing as he did new and often exotic subject matter which he depicted in freely painted colour. For much of his life his work was found unacceptable in official circles; and this late painting may be taken as a personal statement in which he parallels his own predicament with that of the ostracised poet Ovid.

127 Courbet (1819-1877) *Les Demoiselles des Bords de la Seine*

$38 \times 51\frac{1}{8}$

Courbet was to influence most of the Impressionist painters, particularly in his factual treatment of everyday subject matter. See for example the woodland, sea and snow scenes by him in the National Gallery. The present picture is a composition sketch for the much larger picture in the Petit Palais, Paris. The artist would have painted these extremely attractive prostitutes in his studio; and when the completed version of the picture was exhibited at the *Salon* of 1857, the Paris public was outraged: naked goddesses by a river bank were perfectly acceptable, but well-clothed prostitutes were not.

128 Corot (1796-1875) *Avignon from the west*

$13\frac{1}{4} \times 28\frac{3}{4}$

Signed: COROT

Corot visited Avignon in July of 1836 and the view, which shows the medieval palace of the schismatic popes in the centre, was probably painted at that time. In this small picture, Corot creates an effect of immense space and airiness; forms are simplified and delineated, like distances, by subtle changes in tone. Later the artist would create the type of poetic landscape with trees for which he is most famous, and which were much imitated. The freshness of Corot's vision was to influence the Impressionist painters.

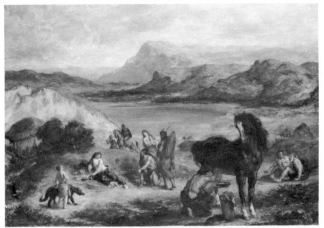

126

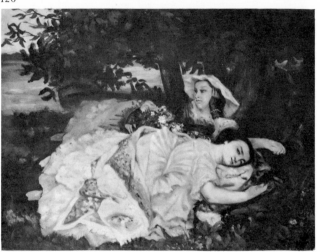

127

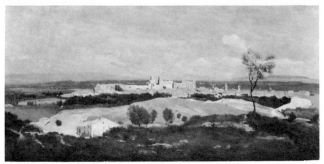

128

129 Manet (1832-1883) *The Waitress ('La Servante de Bocks')*

$38\frac{1}{4} \times 30\frac{1}{2}$

Signed: *Manet/7(9)* (possibly *78*)

At the time the picture was painted brasseries with waitresses were fairly new in Paris and Manet shows the scene inside the Brasserie de Reichshoffen on the Boulevard Rochechouart. The waitress in fact came to Manet's studio to pose, but stipulated that she should be accompanied by her 'galant', who is seated in the foreground of the picture. As a painter of 'modern life', Manet in this late painting records with an Impressionist technique the bustling scene inside the bar.

130 Rousseau (1844-1910) *Tropical Storm with a Tiger*

$51\frac{1}{8} \times 63\frac{3}{4}$

Signed: *Henri Rousseau 1891*

The painter is called 'le Douanier' as he held a minor post in a toll station on the outskirts of Paris. According to himself service in Mexico from 1861 to 1867 provided him with the inspiration to paint the fantastic scenes which are the hall mark of his work. But the charm of his 'deliberately' painted canvases is that they are so decoratively unreal, and so much the products of his imagination; as for example in the present picture where the most exquisitely ferocious tiger bounds through the undergrowth, as he would in the dream of a small child. Rousseau's primitive paintings were ridiculed in his own lifetime; and it was only later that his genius was recognised by Picasso among others.

131 Monet (1840-1926) *The Beach at Trouville*

$14\frac{3}{4} \times 18$

Signed: *Cl. M. 70*

In June 1870 Monet married his model and mistress Camille and took her to Trouville on honeymoon where he worked alongside Boudin and painted this picture. It may show his wife and her sister sitting on the beach. Grains of sand have been discovered in the paint, testifying to the artist's working out of doors; but how else could the shadow on his wife's face have been so brilliantly observed? Within a month war with Prussia broke out, and Monet like many others (Pissarro included) fled to London. There he painted WESTMINSTER and visited the National Gallery, where, according to himself he was unimpressed by the paintings of Constable and Turner.

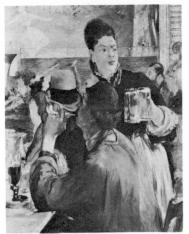

129

130

131

132 Degas (1834-1917) *Woman drying herself*
40⅞ × 38¾

Degas, like Manet, enjoyed painting scenes of contemporary Parisian life: Manet was attracted by the more elegant side of life, Degas favoured the unusual. From the 1870's he relied for his subject matter almost entirely on ballet girls, cabaret artistes and models at their toilet: subjects which are reflected in the paintings by him in the Gallery. He was a superb draughtsman, which, coupled with his interest in photography, enabled him often to depict his models in unusual poses. Degas, whose sight was failing from the early 1880's also experimented with technique: the present picture which was probably painted after that time, is executed in pastel.

133 Renoir (1841-1919) *'Les Parapluies'*
71 × 45¼
Signed: *Renoir*.

This, one of the most famous of all Renoir's paintings, was possibly painted in two stages. The earlier part, the two little girls in the foreground and part of the lady with them, was probably painted about 1881, the remainder of the picture about 1885/86. The difference in technique between the two parts is obvious. The earlier part is executed in a quasi-Impressionist style, the later part is much more firmly drawn. Renoir exhibited at the first three Impressionist exhibitions in the 1870's, but after a visit to Italy in 1881/82 his style became more noticeably formal.

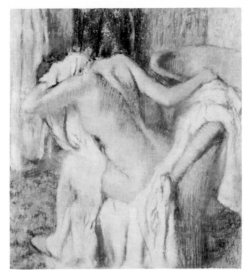

132

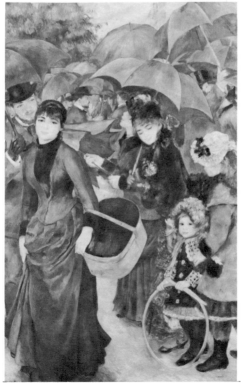

133

134 Seurat (1859-1891) *Une Baignade, Asnières*
79⅛ × 118⅛

Signed: *Seurat*

Asnières is an industrial suburb of Paris; the river is the Seine. The picture, the first of Seurat's large-scale compositions, was painted in 1883/84 before he had evolved fully his theory of *Divisionism*, whereby he applied primary colours in spots on the canvas with the intention that they should mingle in the eye of the spectator to create secondary colours. Parts of the present picture were reworked in that technique, e.g. the orange hat of the boy in the river. The picture has a solemnity and grandeur, the figures an impassive timelessness; and in that they are not unlike the 15th century paintings of Piero della Francesca (fig. 16) which were known to Seurat through copies.

135 Cézanne (1839-1906) *Les Grandes Baigneuses*
50⅛ × 77⅛

In comparison with the type of 16th century treatment of the theme which inspired Cézanne,* these nude figures in a landscape called *Bathers* do not look all that much like bathers any more than THE PAINTER'S FATHER looks like a wealthy French banker (which he was). Cézanne returned to the theme of bathers many times, but the present picture is one of three treatments of it on a very large scale. Dispensing with traditional concepts of anatomy, the artist uses colour to express the forms of what he paints. Here the landscape and figures assume equal importance in the picture, the triangular composition of the group is echoed in the trees and everything is painted in brilliant tones of blue and green. In 'formulating' nature in this way Cézanne prepared the way for Cubism and later developments in 20th century painting.

* See in the Gallery for example Garofalo AN ALLEGORY OF LOVE; Imitator of Giorgione NYMPHS AND CHILDREN IN A LANDSCAPE; and Venetian School 16th Century THE STORY OF CIMON AND EFIGENIA.

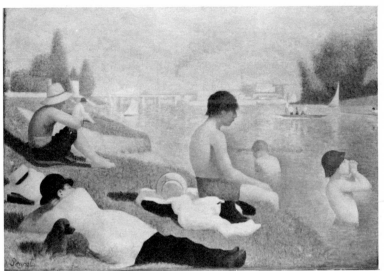

134

135

Room 45 **136** Cézanne (1839-1906) *An Old Woman with a Rosary ('La Vieille au Chapelet')*

$31\frac{3}{4} \times 25\frac{3}{4}$

The sitter was reputedly a nun who, escaping from her convent at the age of seventy, was taken on as a servant by Cézanne at his house Jas de Bouffan near Aix-en-Provence. Although she had reputedly lost her faith, Cézanne himself described how she constantly mumbled prayers. Cézanne's friend Dr Joachim Gasquet is supposed to have found the picture on the floor of the painter's studio with a pipe dripping on it, the damage done is still noticeable in the lower left part of the picture. The picture was probably painted in 1896 at the time when the artist was living almost exclusively at Jas de Bouffan, the house which his wealthy father had purchased.

Room 45 **137** Van Gogh (1853-1890) *Sunflowers*

$36\frac{1}{4} \times 28\frac{3}{4}$

Signed: *Vincent*

In February 1888 Van Gogh, who came from Holland and who had worked in Paris from 1886, went to live at Arles in Provence, where for a time he was joined by Gauguin. At the end of that year he became insane, and from then until he shot himself in July 1890 he suffered repeatedly from mental instability. It was during those first months in Arles that he painted several pictures of sunflowers of which the present picture is one. The Impressionists had been fascinated by the appearance of things, in the paintings of Van Gogh the objects themselves assume a personal significance.

Room 46 **138** Monet (1840-1926) *The Water-lily pond*

$34\frac{3}{4} \times 36\frac{1}{4}$

Signed: *Claude Monet 99*

Room 45
Room 46

In 1890, when he was fifty Monet bought a farmhouse at Giverny, midway between Paris and Le Havre. There, by diverting a stream, he built a water-garden over which he constructed a 'Chinese' bridge and in which he planted IRISES and the WATER-LILIES which were to become his most important subject matter in the last decades of his life. A series of enormous canvases (nineteen of which are in the Orangerie in Paris and one in this Gallery) show the artist experimenting by painting this lily pond in all lights and at all times of the day: experiments which led to paintings, which being devoid of form were simply pools of flickering colour.

136

137

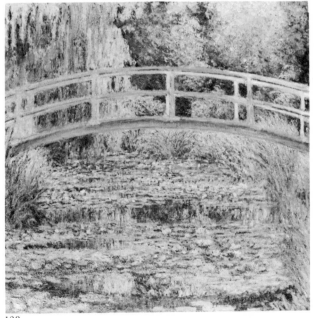

138

9 The Galleries on the Lower Floor

Photograph taken during the Second World War at Manod Quarry in Wales where the National Gallery was temporarily exiled

Atmospheric conditions inside the Manod Quarry, where the collection was stored during the War, proved to be exceptionally favourable to pictures; and experience gained there led to the development of the Scientific and Conservation Departments. Contrary to popular belief, the National Gallery now has no 'cellars', and there are no hidden and neglected masterpieces. The entire collection (with the exception of pictures lent to regional galleries and to temporary exhibitions) is on permanent exhibition at Trafalgar Square.

There are over two thousand pictures in the National Gallery, and all of these, with the exception of pictures lent to regional galleries and to temporary exhibitions, are on permanent display at Trafalgar Square: there is no reserve collection in the National Gallery, and there are no cellars. As a general rule the most important pictures in the Collection are exhibited in the galleries on the main floor, and pictures of lesser importance in the galleries on the lower floor.

Of the pictures in the Collection over half have come by gift and bequest, the remainder have been purchased. To-day it would be unusual for the Gallery to purchase any more than about three or four paintings in a year, but in the 19th century annual purchases might well number about twenty or more. Also, on a few occasions during the last century entire collections were purchased. In 1854 twenty-seven pictures were purchased from the German Krüger collection, in 1857 thirty-one pictures from the Lombardi-Baldi collection in Florence, in 1860 forty-six pictures from the Paris collection of Edmond Beaucousin and in 1871 seventy-seven pictures from the collection of Sir Robert Peel. The substantial bequests of pictures to the Gallery have been mentioned in the earlier sections of this *Guide*.

A visit to the Lower Floor Galleries can afford the visitor many delights and surprises. In the first place those who profess to like picture galleries which look like picture galleries in the old-fashioned sense of the term, that is with the paintings hung from floor to ceiling, will approve of the double and sometimes treble hanging of the paintings on the lower floor. A number of the pictures have not been cleaned, so that the visitor on the one hand, may get some idea as to what pictures galleries were like before cleaning became commonplace, while at the same time appreciate all the better the cleaned pictures exhibited on the main floor. Many of the frames on lower-floor pictures, although often exquisite in themselves, will attract the visitor's attention by their incongruity with the pictures which they frame.

It is not to be imagined that all the pictures in the lower-floor galleries are fakes, copies or even second rate. On the contrary many of them have only reluctantly been consigned to these galleries because of lack of space on the main floor. Among these lesser-known pictures, the visitor will enjoy discovering his or her particular

favourites, and it is such a personal choice which has largely governed the selection of paintings in this section. In addition some curiosities have been included, for all great collections contain curiosities, and in this the National Gallery is no exception.

139 Bernardino Fungai (1460-1516 or later) *Tondo: The Virgin and Child with Cherubim*

$47 \times 46\frac{1}{2}$

The pattern of the Virgin's brocade recurs in other paintings by the artist and is an example of outstanding gilding techniques. The area of the cloak was first covered with gold leaf which in turn was painted over in white. The pattern was then created by removal of areas of white to reveal the gold underneath. The gold areas were then tooled with a pattern. The hem of the Virgin's robe, which is particularly brilliant was also gilded, but then glazed over with a highly translucent scarlet pigment known as Dragon's Blood (in fact a resin obtained from a species of palm tree).

140 Follower of Botticelli (*c.* 1445-1510) *An Allegory*

$36\frac{1}{4} \times 68$

The picture has been called a *Venus reclining with Cupids* but it seems more likely that its real subject is allegorical, and it may well be intended to refer to *Fertility*. It was purchased in 1874 as a pendant to Botticelli's VENUS AND MARS. That picture is also allegorical, showing, as it does, Mars, God of War asleep and Venus, Goddess of Love, possibly bidding Cupids to wake him: suggesting that love is better than war. Ironically the present picture, which is now catalogued as having been painted by a 'feeble imitator of Botticelli', cost £1627 10s, while the real Botticelli only cost £1050. Painted panels of this shape may have been inserted in the wainscoting of a room.

141 Italian School (20th century) *Portrait Group*

$16 \times 14\frac{3}{8}$

This picture was purchased in 1923 when it was thought to be a late 15th-century Italian picture probably representing members of the Montefeltro family of Urbino (whose arms it bears) and possibly painted by Melozzo da Forli (1438-1494). However, the picture is a fake and was probably painted about 1913 upon a worm-eaten panel which is suitably cracked down the middle. The forger may have been an Italian framemaker and known faker, Icilio Federico Joni, and the standing man in the picture, far from being a Montefeltro is not unlike a self-portrait of Joni. Even to the untutored eye, the picture now smacks more of Jugendstil than the Italian Renaissance, but the costumes are the positive clue to the picture's recent date. The girl wears a cap worn only by boys; and the checker pattern of the man's cap, unknown in 1490 was extremely popular by about 1913.

139

140

141

L. Floor A **142** After Francesco Francia (*c.* 1450-1517/8)
The Virgin and Child with an Angel

23 × 17$\frac{1}{2}$

The picture came to the Gallery in 1924 with the Mond Bequest which included paintings by Raphael, Botticelli, Mantegna and Bellini. Until fairly recently it was thought to be by Francia, and indeed was considered his earliest painting. In 1955 an almost identical painting came on the market in London, and after a close examination of both paintings that picture was considered to be the genuine Francia, and the present picture a copy, probably dating from no earlier than the 19th century. Although upon scientific examination all the pigments in the painting proved to be such as Francia could have used, simulated 'cracking' on the surface had in fact been painted on.

L. Floor A **143** Ascribed to Girolamo da Treviso (active 1524—died 1544) *The Adoration of the Kings*

56$\frac{3}{4}$ × 49$\frac{1}{2}$

The picture is a painted version of the Cartoon by Baldassare Peruzzi (1481-1536) which hangs beside it. Vasari described that cartoon in 1550 as being in the possession of the Bentivoglio family in Bologna, and as Peruzzi is recorded in Bologna in 1522/23, it seems likely that the cartoon dates from that time. Vasari also stated that Girolamo da Treviso made a painted copy of the cartoon, and the present picture is thought possibly to be that copy. The painted picture is larger than the cartoon; there is extra space both above and below the heavenly host, and there are also extra figures at the sides.

L. Floor A **144** Circle of the Master of Liesborn (active second half of the 15th century) *S. Dorothy* (left) and *S. Margaret* (right)

Each panel, 31$\frac{3}{4}$ × 19

Photograph taken before restoration showing the extensive retouchings to the panels. These two pictures were once joined together and originally formed part of a much larger altarpiece which probably depicted the Virgin and Child in a garden with Ss. Dorothy, Margaret, Catherine and Agnes. When the two pictures were purchased in 1854 the backgrounds of each panel had been repainted as a flowery meadow in order to hide damages and also to give the impression that each panel was an independent composition. This overpaint was removed in 1961 revealing fragments of the surrounding figures, and the damaged areas were then inpainted in a neutral colour.

142

143

144A

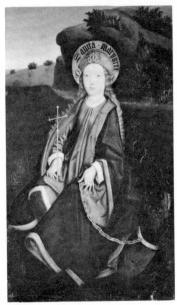

144B

L. Floor A **145** Marinus van Reymerswaele (active 1509?, died after 1567?) *The Two Tax Gatherers*
36¼ × 29¼

From the writing in the book it is clear that the man on the left is a borough or city treasurer, and it is likely that he is composing an account of municipal revenues from imposts on wine, beer, fish etc. The coins preclude a date of execution for the picture before 1526. Other pictures by the artist of similar subject matter exist; they are possibly satirical in intention intended to point to the iniquities of covetousness, usury or extortion. It is unlikely that the figures are portraits and they seem to be dressed in fancifully archaistic costumes.

L. Floor A **146** After Quinten Massys (?) (1465/66-1530)
A Grotesque old woman
25¼ × 18

Room 23

The artist worked in Antwerp and two of his pictures of the VIRGIN AND CHILD ENTHRONED are in the Gallery. The present picture is not acceptable as his work, although its subject matter and the fact that it is connected with a Leonardesque drawing indicates that it may be after Massys who painted such subjects and who was influenced by Leonardo. The sitter has been identified without evidence as Margaret, Duchess of Carinthia and Countess of Tyrol (d. 1369) or alternatively as the 'Queen of Tunis.' The picture is possibly not a portrait but a study in the grotesque, satirising an old woman dressed in youthful clothes and holding a budding rose.* The picture probably inspired Tenniel for his illustrations of the Duchess in *Alice in Wonderland*.

L. Floor B * See the PORTRAIT OF A BOY HOLDING A ROSE, ascribed to the Flemish School, *c.* 1660, which may be a betrothal portrait and the
L. Floor A PORTRAIT OF A MAN who holds two pinks, ascribed to the 16th century South German School, which almost certainly is a marriage portrait.

145

146

L. Floor A **147** Judith Leyster (1609-1660)* *A Boy and a Girl with a Cat and an (?) Eel*

$23\frac{3}{8} \times 19\frac{1}{4}$

Signed: *iudiyh* followed by a star

The artist often signed her pictures with an initial followed by a star, a punning reference to her surname, i.e. *Leidstar*. She was born in Haarlem where she worked for the greater part of her life, and she may have been a pupil of Frans Hals (q.v.). She married the artist Jan Molenaer. This picture may be an illustration of some Dutch proverb or saying, e.g. 'To catch an eel by the tail'. Alternatively, as some similar pictures of happy children are known to express a child's freedom from care, this picture may also be intended to do so.

L. Floor B **148** David Teniers II (1610-1690) *A Series: Spring, Summer, Autumn and Winter*

Each picture about $8\frac{1}{2} \times 6\frac{1}{2}$

Each signed *DT* in monogram, and some with the letter *F* following

At least four other comparable series by the artist are known, and such illustrations of the Seasons were not uncommon in Italian or Flemish art by the 17th century. *Spring* (above left) is a bearded gardener carrying a potted tree in a garden: it would have been more usual for the artist to depict the gardener as a youth. *Summer* (below, left) is a peasant holding a sheaf of corn before a cornfield which is being harvested; *Autumn* (above, right) refers to the wine harvest with a man holding a glass of wine and jug; and *Winter* (below, right) is an old man warming his hands at a cauldron.

* Other female artists whose work is represented in the Gallery include Rachel Ruysch, Rosa Bonheur, Berthe Morisot and Marie Blancour.

147

148

L. Floor A **149** Michiel Nouts (?) (active 1656) *A Family Group*

70 × 92½

At some time prior to 1900 the picture was cut in half: the left half was presented to the Gallery in 1900, the right half was purchased in 1910. The right hand of the girl behind the table is painted part in one half of the picture and part in the other half, establishing beyond doubt that the two halves are indeed parts of the one picture. Much of the picture is damaged, the most satisfactory area is the woman with the child on her lap. The picture was once thought to have been painted by Vermeer.

L. Floor A **150** Gonzales Coques (?1614-1684) *Portrait of a Lady as S. Agnes*

7¼ × 5¾

The identity of the sitter remains unknown; but she is depicted, holding a sword and with a lamb, as S. Agnes. This may allude to her name, or alternatively the picture may be a betrothal portrait: S. Agnes was the patroness of those about to be married. On the basis of costume the portrait was painted about 1680, and the picture is unique in the collection as having been painted on a solid silver panel. Copper panels were frequently used as supports for pictures, particularly during the 17th century, and from the 19th century zinc also was used; but silver supports are exceptionally rare.

L. Floor D **151** Ascribed to Robert Tournières (1667-1752) *La Barre and other Musicians*

63 × 50

The artist of this French portrait, which on the basis of costume is thought to have been painted about 1712, is unknown. It was purchased in 1907 when it was thought to be by Rigaud, and attributions to François de Troy and Robert Tournières have also been suggested. The picture is of the French composer and Flautist Michel de La Barre (*c.* 1674-1743/44), who is probably the figure who leans to turn the page of the music. This is copied exactly from the *Troisième livre de trios, pour les violins, flutes, et hautbois mêlés de sonates pour la flute traversière* (Paris 1707). The well-dressed man seated on the right may be a patron of the composer and various attempts have been made at identifying the other musicians.

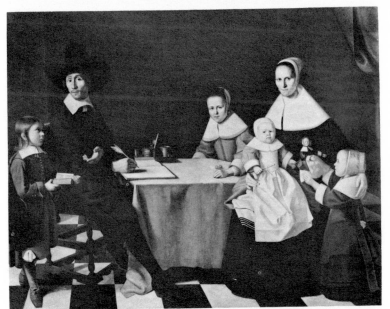

149

150

151

152 Sébastien Bourdon (1616-1671) *The Return of the Ark*

$42\frac{1}{4} \times 53\frac{1}{4}$

The artist trained in Paris and later worked in Rome when he came under the influence of Poussin (q.v.). The Philistines, having captured the Ark of the Covenant from the Israelites, brought it to Ashtod where it caused the idol of Dagon to fall. This is the scene depicted in a picture by Poussin, a copy of which is in the Gallery. The Priests told the Philistines that they must return the Ark, drawn on a cart by two milch cows, together with an offering of five golden mice and five golden emerods. In the present picture the Ark, which has stopped at the stone of Abel, is followed by the five Lords of the Philistines. The picture once belonged to Sir Joshua Reynolds and he referred to it in his *Discourses* as an example of poetic landscape: 'The Ark in the hands of a second-rate master, would have little more effect than a common waggon on the highway.'

153 Italian (?) School, 17th (?) Century, *A Dead Soldier*

$41\frac{1}{4} \times 65\frac{3}{4}$

This picture was thought in the 19th century to be by Veláz-quez, and it was bought as such by the Gallery in 1865. It came from a French collection, and was believed originally to have come from a Spanish Royal Palace. The composition seems to have inspired Manet when painting his picture *The Dead Torreador*, exhibited at the Salon of 1864 and now in the National Gallery, Washington. This, however, was hotly denied by Baudelaire, who said that 'Manet had never seen the Galerie Pourtalès' in Paris, where the present picture was at that time. Attributions to Antolinez (Spanish School, 1635-1675) and Cavallino (Neapolitan School, 1616?-1656) have been suggested for the picture, but its precise date or place of origin remains uncertain.

152

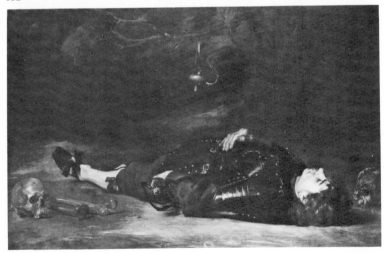

153

L. Floor D **154** Rosa Bonheur (1822-1899) *The Horse Fair*
47¼ × 100¼
Signed: *Rosa Bonheur*

Rosa Bonheur was a French painter whose reputation was
established when she exhibited at the Paris Salon of 1853, a
painting, *The Horse Fair*, now in the Metropolitan Museum,
New York. In order to make studies for the picture she fre-
quented the horse auctions of Paris dressed as a man (for which
she obtained a formal *permission de travestissement* from the
police). The present picture is a reduced version of that famous
painting, and was painted by the artist with the assistance of
her friend Nathalie Micas. The scene is the Paris Horse Market
with the dome of La Salpêtrière in the background.

L. Floor G **155** Sassoferrato (1609-1685) *The Virgin in Prayer*
28¾ × 22¾

Sassoferrato worked in Rome and is particularly associated with
this type of image of a pious *Madonna*. There are other versions
of the design by the artist and also numerous imitations and
copies. In both this picture and the other Sassoferrato in the
L. Floor G Gallery, the VIRGIN AND CHILD EMBRACING, the blue drapery of
the Virgin's robe has blanched, i.e., become pale, a disorder
which is irremediable. The blue colour is called natural ultra-
marine, and is extracted from the semi-precious stone lapis
lazuli. Unfortunately, it is vulnerable to acids which cause the
effect, called 'ultramarine sickness', apparent in both pictures.
This may have happened due to the atmosphere in which the
pictures were exposed, or alternatively the oil medium used by
the artist may have been exceptionally acid.

L. Floor G **156** Pompeo Batoni (1708-1787) *John Scott of Banks
Fee (?)*
40 × 29
Signed and dated: P BATONI PINXIT ROMAE / ANNO 1774

The identity of the sitter is traditional though by no means
certain. Batoni is best known for his splendid portraits of
foreign visitors to Rome and he was particularly patronised by
English Grand Tourists. Many of his portraits still hang in the
English country houses of the families of the sitters who com-
missioned them, and are generally on a much more elaborate
scale than the present picture. Invariably they include in the
background some recognisable tourist attraction such as
Vesuvius or the Colosseum, indicating the sitters' interest in
Antiquity.

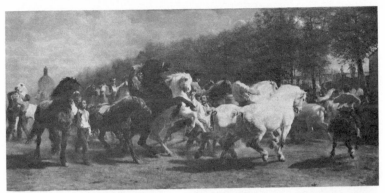

154

155

156

In the following index:

Names of artists are given in bold

Titles of pictures in *italics*

Bold numbers within parentheses, e.g. **(24)** refer to room numbers on the main floor of the gallery

Numbers in *italics* refer to page numbers in the Guide

Normal style numbers refer to illustrations

Albert, Prince *39,40*
Altdorfer (24)
Angelico, Fra **(3)**
Angerstein, John Julius *12*
town house of *1,12,13*
Antonello da Messina **(10)**
S. Jerome 21
Avercamp (28)
A Winter scene with skaters 81
Baldovinetti (3)
Baldung (24)
Balen, Hendrick van
Pan and Syrinx 116
Barbari, Jacopo de' **(23)**
Barnaba da Modena **(2)**
Bartolomeo, Fra **(8)**
Bassano, Jacopo **(9)**
Batoni (38)
Time, Old Age and Beauty 115
John Scott 156
Beaumont, Sir George *12,114*
Beccafumi (8)
Bellini, Giovanni **(10)**
56
Doge Loredan 20
Madonna of the Meadow 19
Berchem, Nicolaes **(16,25,28)**
Berckheyde (16,17)
Grote Kerk at Haarlem 78
Market place at Haarlem 63
Bergognone (14)
Bernini (29)
Bol
An Astronomer 82

Boltraffio (14)
Bonheur, Rosa
The Horse Fair 154
Bono da Ferrara **(12)**
Borch, Gerard ter **(28)**
Bordon (15)
Bosch (23)
Christ Mocked 46
Both (16,25,28)
84
Botticelli (4)
Adoration of the Kings 12
Mystic Nativity 13
Venus and Mars 150
S. Zenobius 30
Botticelli, Follower of
An Allegory 140
Boucher (33)
Pan and Syrinx 105
Boudin (43)
Bourdon
Return of the Ark 152
Bouts (23)
Virgin and Child 27
Boxall, Sir William 6
Bramantino (14)
Breenbergh (19)
Bronzino (8)
An Allegory 44
Brouwer (22)
Bruegel (23)
Adoration of the Magi 32
Brugghen, Hendrick ter **(19)**
Burton, Sir Frederick 6
Campin (23)
40,41
Virgin and Child before a firescreen 29
Canaletto (35)
115
Ascension Day 119
Stonemason's yard 114, 118
Cappelle, van de **(25,26,27,28)**
A River scene 74
Caravaggio (29)
Supper at Emmaus 57,72, 82
Carracci, Annibale **(29,37)**
Domine, Quo Vadis? 59
Carracci, School 57
Castagno (3)
Catena (10)
Cavallino
Christ driving the traders from the temple 110
Cézanne (45)
131
Les Grandes Baigneuses 135

Self-portrait 106
Old Woman with a Rosary 136
Champaigne, Philippe de **(32)**
Richelieu 91,92,94
Chardin (33)
115
House of Cards 115
The Young Schoolmistress 104
Charles I *50,92,93, 94,95,96*
Christus, Petrus **(23)**
Cima (10)
S. Sebastian 30
Claude (32)
94,95
Embarkation of the Queen of Sheba 95
Hagar and the Angel 93
Isaac and Rebekah 94
'The Mill' 94
A Seaport 92
Constable (34)
131
The Cornfield 131
The Haywain 132
Weymouth Bay 121
Coques (22)
A Lady as S. Agnes 150
Corot (43)
131
Avignon from the west 128
Correggio (8)
Madonna of the Basket 15,46
'The School of Love' 47
Cossa, Francesco del **(12)**
Costa, Lorenzo **(12)**
Courbet (43)
131
Les Demoiselles des Bords de la Seine 127
Cranach (24)
Cupid complaining to Venus 35
Crespi (29)
Crivelli (13)
The Annunciation with S. Emidius 24
Cuyp (16,25,28)
76,77
Landscape 72,80
A Milkmaid and cattle near Dordrecht 72,80
David, Gerard **(23)**
Virgin and Child with Saints and Donor 28
Degas (44)
Woman drying herself 132

Delacroix (43)
131
Ovid among the Scythians
126
Delaroche (40)
Detroy (33)
Domenichino (29,31)
Frescoes 57
*S. George killing the
Dragon* 58
Dosso (15)
Dou (17)
Drouais (33)
Duccio (1)
24
The Annunciation 8
*Jesus opening the eyes of a
man born blind* 26
The Maestà 8
The Transfiguration 26
Virgin and Child 24
Dughet (32)
Dürer (24)
The Painter's Father 36
Duyster (28)
Dyck, Anthony van
(21,22)
94,95
Charles I on Horseback
87,88,94
Abbot Scaglia 88
Eastlake, Sir Charles 6,
23,24
Eastlake, Lady 23,94
Elsheimer (29)
Baptism of Christ 60
Eyck, Jan van (23)
40,41
'Arnolfini Marriage' 26,
40
'Leal Souvenir' 25
Man in a Turban 40,42
Fabritius, Carel (26,18)
View in Delft 78
Fiorenzo di Lorenzo (6)
Flaxman, John
Britannia/Minerva 13
Foppa, Vincenzo (14)
Francia, after
*Virgin and Child with an
Angel* 142
Franciabigio (8)
Fungai, Bernardino
*Virgin and Child with
Cherubim* 139
Gaddi, Agnolo (2)
Gainsborough (34)
Mr. and Mrs. Andrews
110,114
Mrs. Siddons 118
The Watering Place 111,
114

Gargiulo, Domenico
(29)
Garofalo (15)
Gauguin (45)
Geertgen tot Sint Jans
(23)
Gentile da Fabriano
(2)
Quaratesi Alterpiece 26
Géricault (43)
131
Ghirlandaio (5)
Giampetrino (14)
Giaquinto, Corrado
(39)
Giordano (29)
Giorgione (10)
56
Sunset Landscape 49
Giotto (1)
24
Pentecost 24
Giovanni di Paolo (6)
*S. John retiring to the
desert* 24
Girolamo dai Libri
(11)
Girolamo da Treviso
(15)
Adoration of the Kings
143
Gogh, Vincent van (45)
Sunflowers 137
Gossaert, Jan (23)
Adoration of the Kings 33
Goya (42)
Duke of Wellington 115,
120
Goyen, Jan van (25,28)
Gozzoli (3)
El Greco (41)
94
*Christ driving the Traders
from the Temple* 103
Guardi (35,39)
115
Guercino (29,37)
*Angels weeping over the
Dead Christ* 62
Hackaert, Johannes
(25)
Hals (26,28)
76,77
*Family group in a land-
scape* 73
Hazlitt, William 12,60
Heyden, Jan van der
(16)
78
Hobbema (27,28)
Avenue at Middelharnis
75,78

Hogarth (34)
114,115,116
Marriage à la Mode 15
The Marriage Contract 109
Holbein (24)
'The Ambassadors' 38,40
*Christina, Duchess of
Milan* 37,40
Holbein, after
Cartoon *'Hans across the
sea'* 5
Holmes, Sir Charles 6
Holroyd, Sir Charles 6
Holwell Carr, Rev.
William 15
Honthorst, Gerrit van
(28)
93
de Hoogh (28)
*The Courtyard of a House
in Delft* 83
Hoogstraten (18)
A Peepshow 65
Huijs, Jan van (17)
Ingres (43)
Madame Moitessier 125
Jardin, Karel du (16,28)
Joos van Wassenhove
(23)
Jordaens (21)
Juan de Flandes (23)
Keyser, Thomas de (28)
Koninck (26)
*An Extensive Landscape with
a hawking party* 75
Krüger collection 40
Lancret (33)
115
*Lady and Gentleman with
two girls in a garden* 106
Lane, Sir Hugh 129,131
Lanino 11
Lastman (19)
*Juno discovering Jupiter
with Io* 82
Lawrence (34)
Layard, Sir Austen
Henry 24
Le Brun, Vigée
Self-portrait 100
Le Nain (43)
Leonardo da Vinci
(7,14)
56
Cartoon 40,56
Virgin of the Rocks 56,58
Leyden School
Young Astronomer 82
Leyster
A Boy and a Girl 147
Lippi, Filippino (3)
Lippi, Filippo (3)
Liss (29)

Lochner (24)
 *Ss. Matthew, Catherine
 and John* 34
Longhi (35)
 *Exhibition of a Rhino-
 ceros* 117
Lorenzo Monaco (2)
Lorenzo Veneziano (2)
Lotto (15)
Lucas van Leyden (23)
Luini (14)
Mabuse, see Gossaert
Maes (26,28)
Mainieri, Gian Fran-
 cesco de' (11)
Manet (44)
 129, 160
 Eva Gonzalès 129
 La Servante de Bocks 129
Mantegna (12)
 25,34,96
 Samson and Delilah 23
 *Virgin and Child with the
 Magdalen and S. John* 22
Margarito of Arezzo
 (1)
Marinus van Reymers-
 waele
 The two tax gatherers 145
Marziale, Marco (11)
Masaccio (2)
 Virgin and Child 9
Masolino (2)
Massys (23)
 Grotesque old woman 146
 *Virgin and Child enthroned
 154*
Master of Liesborn
 (24)
Master of Liesborn,
Circle of
 *Ss. Dorothy and Margaret
 144*
**Master of the Life of
the Virgin** (24)
Matteo di Giovanni (6)
 S. Sebastian 30
Mazo
 Mariana of Austria 95
Melone (15)
Memlinc (23)
 'The Donne Triptych' 31
Metsu (16,17,28)
Michelangelo (8)
 56,60
 The Entombment 41
Michelangelo, after
 *Christ driving the traders
 from the temple 110*
Micas, Nathalie, see
Bonheur
Millet, Francisque (32)
Mola (29)

Molenaer (16)
Mond, Ludwig *24*
Monet (44,46)
 Beach at Trouville 131
 Irises 138
 Water-lilies 144
 Water-lily pond 138
 Westminster 138
Montagna, Bartolomeo
 (12)
Morando
 11
Moretto (30)
Moroni, Gianbattista
 (30)
Murillo (41)
 94
 *Adoration of the Shepherds
 106*
 Self-portrait 98
 Two Trinities 99
Nardo di Cione (2)
Nattier (33)
 Manon Balletti 108
Nazari, Nazario
 Andrea Tron 114
Neer, Aert van der (25)
Nouts
 A Family group 149
Oost, Jacob van (22)
Orcagna (2)
Orsi (15)
L'Ortolano (15)
Ostade, Adrian van (17)
 An Alchemist 82
Ostade, Isack van
 (16,28)
Pacher (24)
Palma Vecchio (15)
Panini (35)
 Interior of S. Peter's 88
Parmigianino (8)
 Alterpiece (S. Jerome) 48
 *Mystic Marriage of S.
 Catherine 56*
Patenier (23)
Peel, Sir Robert, *12,75*
 collection *75,76*
Pellegrini (38)
Perronneau (33)
Perugino (6)
Peruzzi
 Adoration of the Kings 152
Pesellino (2)
Philip IV
 92,94,95,96
Piero di Cosimo (5)
 Lapiths and Centaurs 30
 Mythological subject 15
Piero della Francesca (6)
 142
 Baptism of Christ 16
 Nativity 17

Pintoricchio (6)
Pisanello (12)
 *Virgin and Child with Ss.
 George and Anthony Abbot
 23*
Pissarro (44)
Pittoni (38)
 Nativity 4
Poel, Egbert van (16)
Pollaiuolo (4)
 *Martyrdom of S. Sebastian
 14,25*
Pontormo (8)
Potter (16)
Poussin (32)
 94,95
 *Adoration of the Golden
 Calf 97*
 *Bacchanalian revel before a
 term of Pan 106*
 *Landscape with a man
 killed by a snake 96*
Poynter, Sir Edward *6*
Preda (14)
Preti (29)
Le Prince (33)
Pulzone
 Portrait of a Cardinal 60
Raphael (8)
 56,72,113
 Ansidei Madonna 42
 Julius II 43
 Mackintosh Madonna 55
 *Madonna and Child with
 S. John 55*
 *The Procession to Calvary
 55*
Rembrandt
 (19,26,27,28)
 76,78,106
 Belshazzar's Feast 69
 An Equestrian portrait 80
 A man in a Room 70
 *An Old Man in an Armchair
 79*
 Saskia van Ulenborch 68
 *Self-portrait aged 34 67,
 106*
 *Self-portrait aged 63 80,
 106*
 Hendrickje Stoffels 82
 Jacob Trip 86
 Margaretha Trip 76
 *The Woman taken in
 Adultery 66*
 A Woman bathing 71
Reni (29,37)
 *Adoration of the Shepherds
 61*
Renoir (44)
 'Les Parapluies' 133
Reynolds (34)
 94,114,160

Anne, Countess of Albe-
marle 113
Lady Cockburn and her
children 122
Lord Heathfield 15,114
Banastre Tarleton 114,
115
Ribera (**29**)
57
Ricci (**38**)
Bacchus and Ariadne 66
Rigaud (**33**)
Roberti, Ercole de' (**12**)
Romanino (**30**)
Rosa (**29**)
Self-portrait 106
Rossi, Charles 13
Rousseau (**44**)
Tropical Storm with a Tiger
130,131
Rubens (**20,21,22**)
93,94,95
The Duke of Buckingham
conducted to the temple of
Virtue 95
Cattle by a Stream 120
'Chapeau de Paille' 90
Judgement of Paris 86,95
Minerva protects Pax from
Mars 84,95
A Roman Triumph 85
A View of Het Steen 89
Ruisdael, Jacob van
(**16,26,27,28**)
77
Landscape with a ruined
castle and church 77
Ruysdael, Salomon
van (**17,28**)
Ruskin, John 14,36
Saenredam (**16**)
Saint-Aubin (**33**)
Salting, George 24,76
Sarto (**8**)
Sassetta (**6**)
24
Life of S. Francis 18
Sassoferrato
The Virgin and Child em-
bracing 162
The Virgin in prayer 155
Savoldo (**30**)
Sebastiano del Piombo
(**8**)
Raising of Lazarus 45
Segna di Bonaventura
(**1**)
Seurat (**45**)
Une Baignade, Asnières 131,
134
Signorelli (**6,11**)
Sisley (**44**)
Sodoma (**30**)

Solimena (**29**)
Lo Spagna (**6**)
Spranger (**24**)
Adoration of the Magi 39
Steen (**17,28**)
Music Making on a terrace
64
Strozzi (**29**)
Stubbs (**34**)
114
The Melbourne and Mil-
banke families 112
Taillasson (**33**)
Virgil reading the Aeneid
107
Teniers, David, II
(**22**)
The Four Seasons 148
Tiepolo, G. B. (**38,39**)
114
An Allegory with Venus
and Time 6,115,116
Banquet of Cleopatra 115
Tiepolo, G. D. (**38,39**)
114
Tintoretto (**9**)
57,72
Christ washing the Dis-
ciples' feet 68
The Origin of the Milky
Way 54
Titian (**9**)
56,57
The Death of Actaeon 20,
53,56
Allegory of Prudence 50
Bacchus and Ariadne 52
'Noli me Tangere' 51
? Self-portrait 80,106
Toulouse-Lautrec (**44**)
Tournières, ascribed to
La Barre and other
Musicians 151
Treck, Jan (**17**)
Troy, François (**33**)
Tura (**12**)
Turner (**34**)
15,131
Calais Pier 124
The Fighting Téméraire
123
bequest of pictures 15,
131
Uccello (**3**)
The Battle of San Romano
11
S. George and the Dragon
10
Ugolino de Nerio (**1**)
Valdes Leal (**41**)
Le Valentin (**29**)
Velazquez (**41**)
94

Christ in the House of
Martha and Mary 102
S. John the Evangelist 98
Philip IV, bust portrait
108
Philip IV in brown and
silver 94,100
Philip IV boar hunting
108
'The Rokeby Venus' 101
Velde, van de (**28**)
Velsen, Jacob van (**16**)
Vermeer (**28**)
76,77
A Young Woman standing
at a Virginal 82
Vernet, C.-J. (**33**)
Vernet, Horace (**36**)
Veronese (**9**)
57
An Allegory 56
The family of Darius be-
fore Alexander 55
Verrocchio (**4**)
Victoria, Queen 39,40
Vivarini (**12**)
Vlieger (**28**)
Voet
Cardinal Cerri 60
Vouet (**32**)
Vroom (**28**)
Walscappelle (**17**)
Watteau (**33**)
115
Werff, Adrian van der
(**17**)
Weyden, Rogier van der
(**23**)
40,41
S. Ivo (?) 30
Wilkins, William
2,3,13
Wilson, Richard (**34**)
Wilton Diptych (**1**)
7,24
Witte, Emmanuel de
(**17**)
Wouwermans (**28**)
Wtewael (**16**)
Wynants (**16,28**)
Wynn Ellis collection 76
Zais (**39**)
114
Zoffany (**34**)
Zoppo (**22**)
Zurbaran (**41**)

Index to Rooms

Normal style numbers refer to illustrations.
Numbers in *italics* refer to pages.

Room 1: Early Italian 7,8,*24*

Room 2: Early Italian

Room 3: Italian 15th Century Florence 10,11

Room 4: Italian 15th Century Florence 9,12,13,14,*25*,*140*

Room 5: Italian 15th Century Florence

Room 6: Central Italian 15th Century 15,16,17,18,*24*

Room 7: Leonardo Cartoon 40,*56*

Room 8: Central Italian 16th Century 41,42,43,44,45,46,47,48,*56*,88

Room 9: Italian 16th Century Venetian 50,51,52,53,54,55,*56*,*56*,67,98

Room 10: Italian 15th Century Venetian 19,20,49,*56*

Room 11: Italian 15th Century Altarpieces

Room 12: North Italian 15th Century 22,23,*24*,*25*

Room 13: Crivelli 24

Room 14: Italian 15th Century Milanese *56*,*58*

Room 15: Italian 16th Century

Room 16: Dutch 17th Century 63

Room 17: Dutch 17th Century 63,64

Room 18: Dutch 17th Century 65

Room 19: Dutch 17th Century 66,67,68, 69,70,71,98

Room 20: Flemish 17th Century 84,85, 86,*95*

Room 21: Flemish 17th Century 87,88. *94*

Room 22: Flemish 17th Century 89,90, *95*

Room 23: Early Netherlandish 25,26. 27,28,29,30,31,32,33,*40*

Room 24: German 34,35,36,37,38,39

Room 25: Dutch 17th Century 68,72, 74

Room 26: Dutch 17th Century 73,75, 76,77

Room 27: Dutch 17th Century 78,79,80

Room 28: Dutch 17th Century 81,82. 83,98

Room 29: Italian 17th Century 57,*57*, 58,59,60

Room 30: Italian 16th Century Brescian

Room 31: Domenichino frescoes *57*

Room 32: French 17th Century 91,92, 93,94,*94*,95,*95*,96,97

Room 33: French 18th Century 104. 105,106,107,108

Room 34: British 108,109,110,111,112, 113,114,*114*,*115*, 121, 122,123,124,*131*

Room 35: Italian 18th Century *114*. *115*,117,118,119

Room 36: French 19th Century

Room 37: Italian 17th Century 61,62

Room 38: Italian 18th Century *115* 116

Room 39: Italian 18th Century *115*

Room 40: French 19th Century

Room 41: Spanish 98,99,100,101,102, 103

Room 42: Goya 120

Room 43: French 19th Century 125,126, 127,128,*131*

Room 44: French 19th Century 129,130. 131,*131*,132,133

Room 45: French 19th Century 98,*131*, 134,135,136,137,138

Room 46: French 19th Century 138

Key to Plan

(A) Moving Picture Room

(B) Historical Gallery

(C) Special Exhibition Room

Plan of Rooms on Main
Exhibition Floor

The Gallery is open:

Monday-Saturday 10.00 until 18.00
Sunday 14.00 until 18.00

Tuesdays, Thursdays until 21.00
(1st June to 30th September)

The Gallery is closed:

1st January, Good Friday, Christmas Eve,
Christmas Day and Boxing Day

**The Publications and Information
Stalls are open:**

Monday-Saturday 10.00 until 17.40
Sunday 14.00 until 17.40

Tuesdays, Thursdays until 19.50
(June-September)

**The Restaurant on the Ground Floor
is open:**

Monday-Saturday
10.00 until 15.00; 15.30 until 17.00
Sunday 14.30 until 17.00

Public Lectures are given as follows:

October-May inclusive
13.00 on Monday, Tuesday, Wednesday
12.00 on Saturday

June-September inclusive
13.00 on Monday, Wednesday, Thursday
18.00 on Tuesday

Films and audio-visual programmes are
shown throughout the year.

For information regarding these, special
lecture series, guided tours and children's
activities, apply to the Education De-
partment.

← Fold out

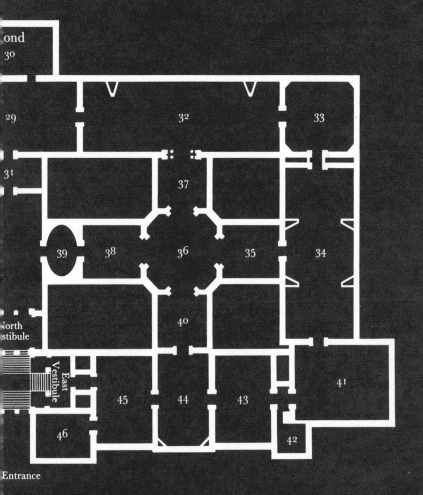

ond
30

29

31

32

33

37

39 38 36 35 34

North
Vestibule

40

East
Vestibule

41

45 44 43

46

42

Entrance

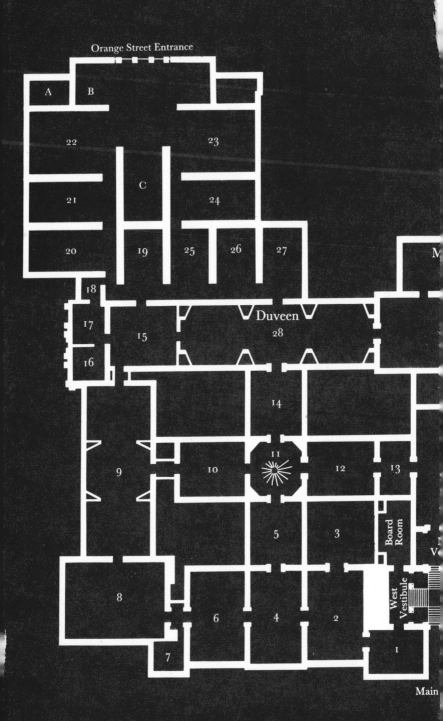

Orange Street Entrance

A B

22 23

21 C 24

20 19 25 26 27 M

18

17 15 Duveen
16 28

14

9 10 11 12 13

5 3 Board Room V

8 West Vestibule 1

6 4 2

7

Main